Table of Contents

Printing of this catalogue was made possible
in part by the generous support of

CHRISTIE'S

This exhibit was partially underwritten by

Republic
Security
Bank

Member FDIC

and

GREENLEAF & CROSBY

and made possible by the ongoing support of
Robert and Mary Montgomery.

00:02

Lenders to the exhibition:

303 Gallery, New York
Colin de Land/American Fine Arts, New York
Carlos & Rosa de la Cruz Collection, Key Biscayne, Florida
Electronic Arts Intermix, New York
Gagosian Gallery, New York
Greene Naftali, New York
I-20 Gallery, New York
Jay Jopling/White Cube, London
Galerie Kienzle & Gmeiner, Berlin
Lisson Gallery, London
Matthew Marks Gallery, New York
Sara Meltzer's on view..., New York
Isabella Prata & Idel Arcuschin Collection, São Paulo
Sonnabend Gallery, New York
Video Data Bank, Chicago
Andy Warhol Museum, Pittsburgh, a museum of the Carnegie Institute
David Zwirner Gallery, New York

making ● time

Considering Time as a Material
in Contemporary Video & Film

Making Time: Considering Time as a Material in Contemporary Video & Film
has been organized as the inaugural exhibition of the
Palm Beach Institute of Contemporary Art
Lake Worth, Florida
March 5, 2000 - May 28th, 2000.

Curator: Amy Cappellazzo
Essays: Amy Cappellazzo, Adriano Pedrosa, Peter Wollen
Editorial Coordinators: Sina Najafi & Nina Katchadourian
Biography Coordinator: Seth McCormick
Designers: Patty Doherty and Derwent Donaldson, Strategic Marketing
Printer: Patrick Sniffen, Benchmark Press, Inc.

PB**ICA**

First Edition © Palm Beach Institute of Contemporary Art

Available through D.A.P./Distributed Art Publishers, Inc.,
155 Sixth Avenue, 2nd Floor, New York, NY 10013-1507
Tel (212) 627-1999, Fax (212) 627-9484

Printed in the United States
ISBN 0-9676480-0-9

A c k n o w l e d g e m e n t s

"Making Time," the exhibition and catalogue, would not have been possible without the support and participation of many individuals and companies. As the inaugural exhibition of the Palm Beach Institute of Contemporary Art, it represents the successful reincarnation of the "Lannan Museum," established in 1980 by Patrick Lannan, Sr. in Lake Worth, Florida to present the seminal works collected by him since the 1960s. In the late 1980s Mr. Lannan's death led to the relocation to the West Coast of his heirs, family and most of the collection. The Museum of Contemporary Art was donated to nearby Palm Beach Community College with some 1,200 collected works. The museum and the small remaining collection were purchased by Robert and Mary Montgomery of Palm Beach in July, 1999, when the college decided to sell.

Robert and Mary Montgomery are widely admired for their generosity as classic philanthropists, particularly in the arts and culture. Their support of the establishment of Palm Beach/ICA is consistent with specific values, beliefs and commitments that have driven their more than thirty years of building cultural institutions. First, they believe in the essential role of the arts in the life of a community. Second, they are committed to education as the critical function of institutions in enriching the intellectual life of society and the workplace. Thirdly, they fully understand the need to build an infrastructure of strong institutions; and fourth, they celebrate the continuum of art-making in the world and the fundamental need of a community to support the artists of its time. Palm Beach/ICA and "Making Time" are metaphors for the vision and generosity of these philanthropists and cultural leaders. We are grateful for their personal interest, time and extraordinary financial support.

Palm Beach/ICA emerged from a four-month research and development effort that led to the definition of its mission, establishment of its institutional identity and the fortunate attraction of Amy Cappellazzo as the leader of its first curatorial efforts. A small group of advisors was approached to define the vision and determine its early components. We are grateful for their expert and thoughtful advice. They are Anne Lannan of the Lannan family and Foundation (Los Angeles); Edward Broida, Collector (Palm Beach and Santa Fe); Rod W. Faulds, Director, University Galleries, Florida Atlantic University (Boca Raton); Michael Govan, Director, DIA Center For the Arts (New York); Kathleen Holmes, Artist and Arts Advocate (Lake Worth); John P. Morrissey, Collector (Lake Worth); Barry Pinciss, former President, MOCA/Lake Worth Advisory Board (Palm Beach); Joanne Warshaver-Pinciss, former Member, MOCA/Lake Worth Advisory Board (Palm Beach); Donald Rubell, Collector and Mera Rubell, Collector (Miami).

00 : 03

A c k n o w l e d g e m e n t s

Regarding "Making Time" itself, the exhibition and catalogue, Amy Cappellazzo has worked tirelessly and brilliantly to accomplish this rare look at film and video art in the modern world. Both her aesthetic and institutional visions have provided the core of our best thinking in making Palm Beach/ICA an innovative and valuable institution.

Other members of the Palm Beach/ICA development team, without which the museum and "Making Time" would not have been possible, include Michael McManus, Interim Museum Manager, who raised the level of museum practice to the required professional standard; Paula Matthews who as Administrative Assistant, kept the details organized; Eugene Lawrence, Palm Beach architect, who managed the structural redesign and retrofitting process of the striking facility; Terry Murphy and the staff of Strategic Marketing (West Palm Beach), for his dedicated management of South Florida marketing and public relations efforts; Patty Doherty and Derwent Donaldson of Strategic Marketing, for their creative design of the Palm Beach/ICA logo and look; and Ruder Finn (New York), for their wise counsel and management of national press and visibility.

We are thankful for the artists whose works make up the content of "Making Time." They are the reason for Palm Beach/ICA's existence.

At the time of printing, for their critical financial partnership with Robert and Mary Montgomery and Palm Beach/ICA, we are very grateful to Republic Security Bank (Florida); Greenleaf & Crosby (Palm Beach); and Christie's (New York) for their partial underwriting of "Making Time."

Sidney J. Brien
Director, Institutional Development

00 : 0 4

A c k n o w l e d g e m e n t s

"Making Time" marks the first exhibition of the new Palm Beach Institute of Contemporary Art. Since the museum is located in a former movie theater, it is fitting that this first exhibition focuses on film and video, as it is both a nod toward future directions in art and an embrace of the past. It also seems apropos that the first exhibition would deal with our notion of time, as we advance into an era where our conceptions of time, because of technology, are ever changing. As with the organization of any exhibition, particularly one involving complex technologies, there is no such thing as an unnecessary detail. Throughout the planning and development of this exhibition, many individuals managed its numerous aspects gracefully.

The architect Eugene Lawrence re-designed the building, making it ideal for contemporary art for years to come. He guided every detail of its renovation with a keen sense of the building's Art Deco history as the Lake Theatre, as well as the future necessities of the Palm Beach/ICA.

Through my research for "Making Time," I have been gripped by an evangelical zeal about the importance and possibilities of film and video in the visual arts. After submerging myself in the discourse of the media arts for the past six months, it seems strange for me now to recall that the idea of mounting a film and video exhibition was not even my own. Sidney Brien, Director, Institutional Development for the Palm Beach/ICA, suggested it and wisely saw it as an opportunity for a new museum to explore edgy territory of the visual arts. His wisdom about the workings of vital arts institutions is uncanny, and I have learned tremendously from his guidance.

00:05

Michael McManus, Interim Museum Manager, and Paula Matthews, Administrative Assistant at Palm Beach/ICA worked in the building with dignity during its noisy, dusty refurbishment. Their patience, diplomacy and perseverance are commendable. Michael McManus' knowledge of museum policy and procedure, as well as his talents for public education were invaluable during the planning stages of the exhibition. Paula Matthews was most helpful during the organization of "Making Time." Her ability to juggle a myriad of details is admirable.

Aaron Davidson and Melissa Dubbin, technology consultants for "Making Time," contributed their exceptional organization, knowledge of video equipment and talents for installation. LOT/EK, comprised of Giuseppe Lignano and Ada Tolla, brought their design prowess to the installation of "Making Time" in addition to thoughtful insights about the physical needs

of a viewer in a film and video exhibition. The result of their research and design development is genius and visionary. I am grateful also for the skill and savvy of Patty Doherty and Derwent Donaldson, both of whom oversaw the design and production of this book. The staff at both Strategic Marketing in West Palm Beach and Ruder Finn in New York proved creative and prescient in all matters of public dissemination of information.

For the content and organization of this exhibition publication, Peter Wollen and Adriano Pedrosa were both perceptive and insightful in their writings about matters of time in film and video. Peter Wollen's earlier texts on film were especially helpful to me; and I am grateful to Adriano Pedrosa for his collegiality and lively conversations about the nature of art and time. Sina Najafi and Nina Katchadourian were astute in their editing, and I am grateful for their suggestions. My invaluable curatorial assistant Seth McCormick contributed greatly by preparing the artists' biographical information. Without the help of my capable assistant Adria Marquez, this project would not have been realized on time.

00:06

For their goodwill and assistance in locating works and making loans, I am grateful to the following: Carlos and Rosa de la Cruz; Isabella Prata and Idel Arcuschin; Geralyn Huxley and Greg Pierce at The Andy Warhol Museum; the staff at Video Data Bank and Electronic Arts Intermix; Dani Garah at Jay Jopling/White Cube; Lisa Rosendahl and Jari Lager at Lisson Gallery; Colin de Land at American Fine Arts; Sara Meltzer at Sara Meltzer's on view; Angela Choon and David Zwirner at David Zwirner Gallery; Kay Pallister at Gagosian Gallery; Carol Greene and Sima Fabrikant at Greene Naftali; Lisa Spellman at 303 Gallery; Paul Judelson at I-20 Gallery; Leslie Cohen at Matthew Marks Gallery; the staff at Sonnabend Gallery; and Jochen Kienzle at Galerie Kienzle & Gmeiner.

Among the most important acknowledgements are for the artists in the exhibition. It is often said that without artists, there would be no exhibitions, nor museums. While this statement has become cliché, it is no less true. An enormous thanks is in order to all the artists in "Making Time."

Finally, my gratitude and profound respect go to Robert and Mary Montgomery, founders of the Palm Beach Institute of Contemporary Art, for their visionary thinking, gracious patronage, and their interest in and support of the art of our time.

Amy Cappellazzo
Curator

Time In
Video and Film Art

Peter Wollen In their understanding of time, the artists' works in "Making Time" are curiously reminiscent of some of the very first films made by the Lumière brothers at the end of the nineteenth century, films sometimes known as 'primitive.' Made before the appearance, development and triumph of editing or montage, these earliest films simply show one continuous action or event, which begins at the beginning of the film and ends as it ends. Even at the dawn of cinema, it is worth noting, the Lumière brothers seem to have taken care to time the action of their films so that the ending of the film coincided with the end of the event filmed. Thus, in their famous *Workers Leaving the Factory*, the film begins with the factory gates opening, continues while more workers stream out and concludes with the gates being closed. Thus, in André Gaudreault's words, "the film opens, presents one action through to its conclusion and then ends." This is not exactly a narrative, because there is no causal chain involved, linking one event to another, but simply a single event, with no consequences except that all the participants have exited the frame by the end of the film, except for a couple of onlookers who may be gate-keepers or something of that kind.

00 : 07

Some of these films are clearly staged for the camera, unlike the workers who would leave the factory whether there was a camera there or not, and thus begin to take on a dramatic quality which places them, perhaps, at the threshold of narrative. Thus, in *A Game of Cards*, our attention is monopolized by a waiter who is clearly over-performing for the camera, pointing hysterically at the cards, as Richard De Cordova describes it, and "laughing as if in a fit." This is not something he would reasonably be doing if there was no camera present. *Feeding the Baby* falls into the same category of film, showing the self-conscious reactions of onlookers as the baby is prodded into consuming its meal. Eventually the Lumière brothers made a film which is customarily considered as crossing the threshold into dramatic narrative—*L'Arroseur Arrosé*, which might be translated *Watering the Waterer*, a single shot film which shows a gardener spraying with a hose, until a mischievous young lad steps on the hose, thereby stopping the flow of water, until the gardener looks down the nozzle in search of the blockage, whereupon the mischievous boy releases his foot and thereby soaks the gardener, who pursues him off-screen in a rage. Many scholars of early cinema still tend to argue, however, that although this film shows us a story in dramatic form, it cannot yet be said to have told the story, to have narrated it. Telling, in their view, involves moving beyond the single-shot film to the edited film, within which the story is deliberately shaped, shot by shot, rather than simply recorded by the camera.

Many artists' videos, it seems, are atavistic works, deliberately returning to the single-shot technique which ruled at the very dawn of cinema, setting up a continuous action and then filming it within a given time limit without any edits or even camera movements. In this respect, artists' videos simply followed in the footsteps of avant-garde film, which preceded video during the 1960s. In his book, *Back and Forth: Early Cinema and the Avant-Garde*, Bart Testa discusses at length the fascination which avant-garde filmmakers felt for the very first epoch of their art, deliberately echoing its simplicity and apparent naiveté. In Testa's words, avant-garde film-makers were "fascinated with the origins of their art, however unattainable and mysterious these prove to be." The crucial films for Testa are Ken Jacobs's *Tom, Tom, The Piper's Son*, made in 1969, and Ernie Gehr's *Eureka*, made in 1974. To make *Tom, Tom, The Piper's Son* Jacobs simply re-filmed a 1905 film of the same title from the screen, closing in on particular areas or details with a wandering camera to create, in his own words, a "dream within a dream," a subjective journey which re-frames, re-creates and re-loops the original, seizing obsessively on a stray detail, re-focussing and re-framing it to bring out its mystery and beauty. In contrast, Ernie Gehr's *Eureka* elongates the film, a view from a trolley-ride in San Francisco in 1903, by freeze-framing every single frame so that the original effect of continuous movement is arrested and transformed into a discontinuous series of still images, a kind of freezing of Zeno's arrow of time, as Testa points out. In fact, both Jacobs's and Testa's film elongate their original, by looping or by freeze-framing, both drawing attention to their own work of re-filming and decelerating the original, slowing it down contemplatively.

We can find a similar effect, taken to more extreme lengths, in the films of Andy Warhol, such as *Sleep* (1963) or *Empire* (1964), each consisting of a series of consecutive shots laid end to end, with total lengths of 5 hours 20 minutes (projected at below standard speed) and 8 hours 5 minutes respectively. In *Sleep* and *Empire*, of course, action or even change of any kind is extremely minimal – indeed almost nothing happens although there are bouts of snoring in *Sleep* and the building lights are switched off and on to dramatic effect in *Empire*. *Sleep*, it should be added, was criticized at the time by Warhol's friend Taylor Mead, who dismissed it as a "fraud," because it used repeated footage. As with Jacobs and Gehr, in fact, Warhol deliberately slowed his work down, influenced, it seems by attending a concert organized by John Cage, featuring Eric Satie's piano piece, *Vexations*, a work which lasted for 18 hours and 40 minutes, in which a single 80-second piece was repeated 840 times by different pianists. Warhol discussed the use of repetition with Cage following this concert, but never used repetition or indeed any kind of editing again after his experience with *Sleep*, explaining that he found it too "tiring." Perhaps an even more significant work by Warhol, however, was *Eat* (1964), a 39-minute film (at the slow projection speed of 16 fps) in which Warhol filmed Robert Indiana eating a mushroom, as instructed, as slowly as possible, managing to make it last for as long as 27 minutes, further extended by Warhol's choice of projection speed.

Eat is a crucial film in relation to the use of time in subsequent artists' videos, because it combined a completely neutral film-making style with a deliberately time-based performance (eating a mushroom as slowly as possible). In contrast, the sleeping John Giorno or the Empire State Building had nothing to do except sleep and be there, both unconscious activities. Indiana, on the other hand, received instructions which he was asked to follow consciously and deliberately. Task-based work of this kind eventually became a staple of artists' video work. It also bears some relation to the documentation of artists' performance on film which was already frequent in the early 1960s, although Indiana's performance took place simply in order for it to be filmed by Warhol, without any public existence of its own—enacted on a closed set, so to speak, with an eventual film screening as its only *raison d'être*.

A task-based performance, like Indiana's for Warhol, necessarily poses a new kind of problem for a film-maker or a video-maker. Put simply, it creates a new kind of suspense. Watching a film such as *Sleep*, we may wonder how long it will last before the sleeper awakes, what the duration of sleep will be, but we also know that this is an outcome over which the sleeper has no control. Robert Indiana, however, is consciously attempting to prolong the time span of his performance and hence of Warhol's film. He is actively engaged in postponement and we thus become aware of him as a performer with two apparently contradictory goals—the primary task of eating a mushroom and the secondary (suspenseful) task of delaying completion of the first task for as long as possible. If we look at John Cage's work, we find a very similar program within the field of music, another time-based art. While he was teaching at Black Mountain College, Cage gave just one lecture—a 'Defense

00 : 09

of Satie'—in which he put the case for the importance of duration as a structuring idea in music, as a primary characteristic carrying more weight than that of harmony. "With Beethoven," Cage noted, "the parts of a composition were defined by means of harmony. With Satie and Webern they are defined by means of time lengths. The question of structure is so basic, and it is so important to be in agreement about it, that one must now ask: Was Beethoven right or are Webern and Satie right?"

Cage had no doubts about the answer: "I answer immediately and unequivocally, Beethoven was in error, and his influence, which has been as extensive as it is lamentable, has been deadening to the art of music. Now on what basis can I pronounce such a heresy? It is very simple. If you consider that sound is characterized by its pitch, its loudness, its timbre, and its duration, and that silence, which is the opposite and, therefore, the necessary partner of sound, is characterized only by its duration, you will be drawn to the conclusion that of the four characteristics of the material of music, duration, that is time length, is the most fundamental." Silence, Cage goes on to note, "cannot be heard in terms of pitch or harmony: It is heard in terms of time length." Cage went on to note that "before Beethoven wrote a composition, he planned its movement from one key to another—that is, he planned its harmonic structure. Before Satie wrote a piece, he planned the lengths of its phrases." This, of course, is the same procedure that Warhol followed in his film-making. In a visual form such as film or video, as opposed to a musical form, the word "harmonic" would find an equivalent in a word such as "dra-

matic," just as "melody" would find a rough equivalent in a term like "narrative." Thus Warhol planned the lengths of his shots before filming (each the length of a film roll) as opposed to a Hollywood film-maker who decided the lengths of shots in the editing, as a function of their narrative and dramatic value. Similarly, Warhol was concerned with the duration of actions rather than their dramatic quality or impact. This aesthetic, derived ultimately from Satie via Cage, was the one which finally fed through into the work of artist video-makers.

John Baldessari's *Four Minutes of Trying to Tune Two Glasses (for The Phil Glass Sextet)* in "Making Time," for instance, is dominated by a ticking alarm clock set for twelve o'clock, establishing a limit on the ongoing activity of tuning glasses, its ticking providing an insistent rhythm, terminating in silence as the alarm finally stops ringing. Vito Acconci's *Centers* displays a pointing arm—the artist's own arm presumably—showing the tremors, slight readjustments of posture, the wavering and deep breathing, the determined pointing and straightening of the head which signify a grim determination to keep the arm horizontal as long as the tape keeps running, until it ends. In Bruce Nauman's *Pulling Mouth*, there is a rhythmic and then continuous drilling sound as the camera moves very slowly in towards an open mouth, before eventually stopping, starting and losing focus as the tape ends. Each of these works depicts an ongoing action with an increasingly insistent affirmation of the passage of time, shown by symptomatic actions or visible changes of state, concluding eventually, as the tape approaches its end, with the ongoing signs of an action itself approaching termination, due to completion of a schedule or simply loss of energy, until sus-

pense is finally lifted as the tape runs out of time. These works are somehow about their own suspenseful descent toward inertia.

Film and video art, however, exhibit only a small fraction of the possible ways in which time can be used and understood. Time, which we tend to think about in purely linear terms, is in fact incredibly complex. In Roget's *Thesaurus*, for example, there are hundreds of time-related words listed under such semantically various headings as Neverness, Period, Indefinite Duration, Contingent Duration (provisionally, as long as it lasts, etc.), Long Duration, Transience, Endless Duration, Instantaneity, Priority, Posteriority, Present Time, Different Time (some other time, once upon a time, etc), Synchronism, Futurity, Past Time, Newness, Oldness, Youth, Age, Earliness, Lateness, Timeliness, Untimeliness, Frequency, Infrequency, Regularity, Irregularity, Change, Permanence, Cessation, Continuance, Recurrence, Reversion, Relapse, Changeableness, Anticipation, Memory, Expectation, Preparation, Cause and Effect, Continuity, Discontinuity, Destiny and so on, running the whole gamut of temporality from Beginning to End. In any consideration of video art or experimental film (which, to me, are strongly overlapping if not quite identical categories) the great majority of these terms seem relevant and applicable—there is even a sense of destiny in Acconci's holding his arm straight out in front of him for the continuing duration of his tape, a certain knowledge that the arm must eventually fall, combined with an uncertainty as to exactly when, whether before or after the tape comes to its anticipated end.

On the whole, however, we can simplify the issue of time by looking at the way in which it functions in literature, in speech and language. In verbal discourse, the development of time-related syntactic forms has clearly taken place as a function of the priorities we have given, over time, to clear and effective communication. This has influenced not only the semantics but also the syntax of language, categories built in to the formal structure of the language, into its 'grammar,' rather than categories expressed in its vocabulary, in the meanings of individual words. The three most important of these time-related syntactic categories are tense, aspect and modality. Indeed, scholars of linguistics have argued that these are the basic categories which all languages have in common and which are the first to develop when new languages are created—as when creole languages were created as a result of the movement of slaves or indentured labourers from different language communities into a new environment where they needed to create ways of communicating both with each other and with their masters. These languages—pidgins, creoles—provide the best evidence we have for theories about the origin of languages. They are more basic, they lack the complexity of more developed languages and thereby reveal more about the fundamental structures of communication—especially in their articulation of time.

First, tense. In any narrative, any telling of a story, whether as gossip or as literature, there is a need to distinguish between events in the past, present and future, and these distinctions of tense are staples of any language. In narrative cinema, they appear in the form of 'flashbacks' or, in the case of the

00:11

future, 'flash-forwards'—flashback-like visions or dreams. These time-shifted sequences are embedded in the continuous present of a narrative, which can be marked as past, present or future in relation to the time in which the spectator watches the film, through costume, for instance, or through direct verbal information. Of course, as a film or video itself becomes an object from the past, this temporality is itself transformed, so that we get an effect of a 'past-within-the-past' or even, as in old science fiction films, a 'future-in-the-past.' In fact, the range of the future tense, in a number of spoken languages, overlaps with that of modality, the aspect of language which conveys uncertainty as to reality—conditionals, subjunctives, optatives, all the forms which convey what may, could, might, should have happened or hopefully would happen if… right through to future events that simply 'must' happen, as if the 'if-ness' of the future could be unfailingly countermanded.

00:12

Besides tense and modality, the third basic temporal category is that of aspect, which covers the status of events as just beginning, continuing, persisting and ending or having ended. It is precisely this spectrum of transition which we see in tapes like those of Acconci or Baldessari. In John Baldessari's *Four Minutes of Trying to Tune Two Glasses (for The Phil Glass Sextet)*, the transitions between beginning, continuing, persisting and ending are clearly made visible by the on-screen alarm clock. In Shigeko Kubota's *My Father*, there is a much more complex presentation of time—the artist's look is explicitly retrospective, looking back to an ending which is already in the past, the end of her father's life. It is a film about an ending which has already

happened, but which in flashbacks to her father's death-bed is shown as still to come, anticipated and increasingly expected. It is a tape about recollection—looking back from the present on events in the past—and about mourning, which has its own complex temporal structure, a combination of remembrance with a sense of loss, of a time which has gone, never to be repeated. It is also a film about ending—about a life as it ends, preserved on tape and then included in a work of art which must itself come to its end.

The important point to note is that film and video, unlike painting or sculpture, are both explicitly time-based media. Often this is simply taken to mean that each work exhibits change through time and has a specific duration. In fact, however, the relationship of film and video to time is much more complex than that. It involves many different and complex ways of presenting time, constructing time and thinking about time. In this respect, film and video function in very similar ways. At this point I want to make a polemical claim, perhaps one which is less controversial than I think: the differences between film and video are contingent rather than essential, certainly as far as the art world is concerned. The difference between them is rather like the difference between drawing with a pencil and with a pen or a stick of charcoal. These are all forms of drawing, although they use quite different craft tools or 'technologies.' Video replaced film for many artists around the end of the 1960s principally because it was easier to use, less complex technically. Among other things, it permitted artists to shoot works with a longer continuous duration than film, without the trouble of reel changes. Film and video have each developed their own traditions

and their forms of distribution and presentation are quite different, but these divergences are really of secondary importance, especially with the development of digital technology as an editing tool.

Video, like film, is a time-based medium using recorded light, primarily (although not exclusively) to represent the world in a 'realistic' manner and to display it on a screen. The quality of light on a television screen is different from that on a film screen just as the quality of ink on an etching is different from that on a lithograph. While we should acknowledge that there are some minor differences between the two media in their capacities for using time—for instance, in their ability to freeze time—we should accept that, on the whole, these are of minor significance. In fact, just as Cage noted about music, it is time that is the primary element in both kinds of work. Artists' video, however, tends to recognize the primacy of time as duration, whereas artists' work with film is more likely to fragment linear time and re-distributes it in the interest of narrative complexity. In rejecting or minimizing cinematic narrativity, video both pays tribute to the early years of film (and to its belated rediscovery in the 1960s) and confirms its structural affinity to modern music, to an alternative tradition based upon duration rather than upon story-telling and drama.

Books Consulted:
Bernard Comrie
Aspect (Cambridge: Cambridge University Press, 1976)

Regina Cornwell
Films by American Artists
(London: Arts Council of Great Britain, 1981)

Thomas Elsaesser, ed.
Early Cinema (London: BFI Publishing, 1990)

Gérard Genette
Narrative Discourse
(Ithaca, NY: Cornell University Press, 1980)

Paul J. Hopper
Tense-Aspect: Between Semantics and Pragmatics
(Amsterdam/Philadelphia: John Benjamin, 1982)

Stephen Koch
Stargazer: Andy Warhol's World and His Films
(New York: Marion Boyars, 1985)

Richard Kostelanetz, ed.
John Cage: An Anthology (New York: Da Capo, 1991)

Peter Mark Roget
Roget's Thesaurus (London: Longman, 1992)

Jon Stout, ed.
The Films of Andy Warhol (Los Angeles: Filmforum, 1994)

Bart Testa
Back and Forth: Early Cinema and the Avant-Garde
(Toronto: Art Gallery of Ontario, 1992)

00:13

Peter Wollen is a professor of film at the University of California, Los Angeles and the author of numerous books on art history and film theory including "Signs and Meaning in Cinema" (Indiana University Press), "Addressing the Century: 100 Years of Art and Fashion" (University of California Press) and "Raiding the Ice Box: Reflections on Twentieth Century Culture" (Indiana University Press). He resides in Los Angeles.

Making Time: Considering Time as a Material in Contemporary Video & Film

00:14

Amy Cappellazzo The history of the moving image begins in the late nineteenth century with the invention of cinema. Powered by electricity and light, film allowed for the first time the documentation of movement. As discussed in Peter Wollen's accompanying essay, the very first films simply recorded a continuous activity or event as it occurred in real time. The urge felt by film and video artists, both earlier in the twentieth century and today, to "make time" by recording something in relation to its temporal possibilities is as powerful as was the desire of the Impressionists to "paint light." Emerging out of photography, but with the additional capacity to record movement and visualize the passage of time, film was so revolutionary and influential that it is clear that "the projected cinematic image is […] the single most powerful influence on the arts in the twentieth century."[1]

Cut to the mid-twentieth century. Film, a costly, cumbersome medium, was expanded by the development of 16mm, 8mm and Super 8mm film stocks. These smaller film stocks were affordable and accessible to all, including artists, and this meant that working in film no longer required the technical or financial support of the motion picture industry. These new film stocks and cameras offered portability, flexibility, and an easy, hands-on approach. One could even learn to use them without instruction. By the middle 1960s, the artist-as-filmmaker was redefining the tradition of the artist in the studio, and the genre of avant-garde or experimental filmmaking was born. The first generation of experimental film makers, including Stan Brakhage and Andy Warhol, favored the articulation of each frame of the film—either as a way of moving from representation to abstraction, as in the case of Brakhage, or using the repetition of the same frame to emphasize its importance and play with the boundary between film and photography, as in the case of Warhol. The "flicker" film, pioneered by Peter Kubelka and expanded upon by Paul Sharits, "gave the viewer the sense that he or she could actually see each frame passing through the projector's gate."[2] All of these strategies sought to dilate real time, and thus make disjointed one's sense of action in time.

In 1965 the Sony Corporation introduced the Portapak, its first portable videotape recorder and player. It was the first video camera aimed at the consumer market, and legend has it that the first "consumer" to buy this equipment and use it was the artist Nam June Paik.[3] Perhaps the most important quality of video was its ability to show in "real" time on the cathode ray tube what the camera was recording at each second. In addition to Paik, many artists purchased Portapaks and took to the streets, retreated to their studios, or began performing in front of the camera to see what new imagery might emerge. Everywhere, artists were fascinated by the possibility of completely reshaping our conception of the moving image, both in a popular capacity via television and in art. "Artists working with video in the early 1960s were engaged in a utopian impulse to refashion television into a dialogue of visual and auditory experiences that would allow them to reconstitute themselves as an ever-renewing community of artists."[4] Paik, Vito Acconci, Steina and many other video innovators sought to challenge the power of television, while using its essential form as a force within their challenge.

Video has had a different passage into the visual arts than film, however. The art establishment of the 1960s was suspicious about video's capacity to distinguish itself from television or the didactic usefulness of the documentary. Perhaps because video was so easy to use, so convenient, and so democratic in its function, it was difficult for many to imagine that video could generate the "aura" one expected from a work of art. Film, on the other hand, was immediately accepted as an art form, and even as one with avant-garde possibilities. Film, less burdened by functional duties, was free to experiment to the outer limits of narrative, technique and formal structure. Film theorists have postulated that film shares a closer rela-

00:15

tionship to photography than to video because it is based in celluloid. Video, on the other hand, has its genealogy within a different technical family tree. It may be related to both film and photography conceptually, but not formally. Video's origins are in the magnetic world, not the material plastic one, and it shares its form not with another high art medium but with television. Inherent in video's real time capacities is a "special element [...] that separates it from either film or photography: its analogy to consciousness and, by extension, to being."[5] "Making Time" was organized on the premise, however, that while there are indeed many technical and historical differences between film and video, their shared intrinsic connection to the temporal overrides their differences.

Nearly every cultural theorist of the time, from Marshall McLuhan to Jean Baudrillard to the popular, over-the-top Alvin Tofler, had addressed how television was vying for and in some instances replacing American society's sense of what was real in the world. Similarly, in the late 1960s and early 1970s, television was transforming our sense of time. If indeed epic events could be recorded, edited and processed in a hyper-elapsed period of time (as in Stan Douglas' *Evening*), what patience would remain to experience something in real time? The prospect of watching a recorded event in real time often ruffles audiences, as they prepare themselves for inevitable boredom. Perhaps this is because television and movies have trained modern viewers to expect life in condensed narratives, with scenes of heightened action and sound accompaniments that echo our emotions.

Western philosophical discourse has a relationship to time that, in general, does not emphasize an awareness of the present moment as an opening to higher religious or philosophical awareness. There is no religious or philosophical practice like Zen, for example, which frames what we would call "real time" as an opportunity for deeper contemplation and, ideally, understanding of our human condition. But perhaps ironically, the capacity to be conscious of an action and experience it as it takes place in the present, in real time, is a meaningful moment in the West that we have largely learned through the media. Television has played a crucial role in articulating this, as witnessed by Neil Armstrong's walk on the moon, the Watergate hearings, the chase of O.J.'s white Bronco, and the recent violence at Columbine High, to name a few examples. Many of the artists in "Making Time," notably Bruce Nauman, Andy Warhol and Lynda Benglis, are fixated on real time as well, though their strategies are highly anti-television in that they steer away from high drama and instead favor the highly ordinary and anti-heroic.

Unlike the other disciplines categorized as visual art forms, both film and video are, at their essence, time-based. While the works might not have a specific beginning or end, they are understood to change in some way through the passage of time. It is critical to note that film and video formally share a stronger bond with music and the performing arts, such as dance or theatre. Recently, the marriage of sculpture to film or video has made way for the genre known as video installation. Many artists, including Diana Thater, Lucy Gunning, José Antonio Hernández-Diez, Peter Sarkisian and

Dara Friedman in "Making Time," have joined the physical and material concerns of sculpture with the moving and temporal properties of film and video. These artists use monitors and projectors as sculptural forms, challenge the ideological underpinnings of the pedestal, and occasionally present the projected image as if it had no real connection to the history of picture-making and was a mere by-product of a sculptural system instead.

Time as a material in film and video in fact finds an unlikely kinship in the Minimalist works of the 1960s. Minimalist sculpture in particular required the viewer to assign meaning by piecing together a narrative from the work's scant clues. The time it takes to interpret a work of this sort is critical to its "aura." The Minimalist sculptor Carl Andre said he was interested in the "now, […], the materiality, the presence of the work of sculpture in the room."[6] Also characteristic to the works of Andre, Richard Serra, and others was a romantic attraction to permanence, guiding both the essential nature of the forms chosen as well as the materials. Wanting to work with heavy, static elements was, in the words of Lucy Lippard, "a way of getting around the flux of the modern world, of stopping time."[7] This same urge to stop time, or at least suspend it indefinitely, is evident in the works of Douglas Gordon, Andy Warhol, Darren Almond, Stephen Murphy and Andrea Bowers. Whether the artists explicitly refer to Minimalist sculpture or not, they all refer to art history's relation to perpetuity and to the idea of art as permanence. The English poet and mystic William Blake stated, "Eternity is in love with the production of time." Echoing this same train of thought, it can be said that art is in love with the creation of its own history.

Time had for centuries been connected to the idea of permanence in art history. In the 1960s and 1970s, artists became concerned with time as it related to temporary artworks or types of art, such as performance. From the 1960s through the 1990s, two generations of conceptual artists became consumed with the mechanics of determining the historical value of a work of art. From the semiotic investigations of Joseph Kosuth in the 1960s to the memorial-like works of Felix Gonzales-Torres in the 1980s and 90s, conceptual art in its various manifestations has always incorporated the value and passage of time into its meaning. Minimalism led the way for performance, conceptual art, and film and video to expound upon the meaning of time and use it as both a subject and a material in contemporary art. But where is time now? In an age when global events are shared worldwide in real time, artists have responded by producing works that challenge our conventional notions of time by altering clocks, memory, constancy, documentation, movements, actions, and our sense of loss and gain. Time, after all, is a universal language, yet it is perhaps the least commonly understood.

1. John Hanhardt, "The Media Arts and the Museum: Reflections on a History, 1963 1973," in *Mortality Immortality? The Legacy of 20th Century Art,* ed. Miguel Angel Corzo, (Los Angeles. The J. Paul Getty Trust, 1999), p.95.

2. Rosalind Krauss, "Moteur!" in *Formless: A User's Guide*, eds. Rosalind Krauss and Yves Alain-Bois, (New York: Zone Books, 1997), p.137.

3. Deidre Boyle, "A Brief History of American Documentary Video," in *Illuminating Video: An Essential Guide to Video Art*, eds. Doug Hall & Sally Jo Fifer, (New York: Aperture, 1990), p.51.

4. John Hanhardt, "De-Collage/Collage: Notes Towards a Reexamination of the Origins of Video Art," in *Illuminating Video*: *An Essential Guide to Video Art*, p.73.

5. Marc Mayer, *Being & Time: The Emergence of Video Projection*, exhibition catalogue, (Buffalo, New York: Albright Knox Art Gallery, 1996), p.30.

6. Lucy Lippard, "Time: A Panel Discussion," *Art International*, vol. XIII/9, November 1969, p.22.

7. Ibid., p.23. This same interview is cited in Jean-Christophe Royoux's essay "The Narrative Landscape, or, the Fate of Cinema in the Era of Its Reproduction," in *Perfect Speed* (Guelph, Ontario & Tampa, Florida: MacDonald Stewart Art Centre and University of South Florida Contemporary Art Museum, 1995-96), p.17. Royoux's emphasis on the importance of this panel discussion influenced my own perceptions about the relationship between minimalist sculpture and early video works.

Re-making
Time

A d r i a n o P e d r o s a There is a strange quality in the air today. Although still rather cold, for the first time this year one senses the spirit of spring approaching in a subtle yet definite manner. It is one of those rare days when one perceives so distinctly the slow and quiet change of seasons. Walking along the boulevard at dusk, the flâneur notices signs of awakening in the boulevard's trees and bushes after a long retreat.

0 0 : 1 9

The city is unusually empty today. The reddish light of the setting sun hits the city grid and its streets in a slanted manner. Few pedestrians, occasional cars, many buildings, architectural details, and signs of different purposes and meanings cast sharp shadows on the pavement and the architecture. After several blocks, the flâneur sits on a city bench, a solid and minimalist piece of grayish stone, and observes the line of buildings of different periods neatly arranged on the long and wide boulevard. His attention is drawn to an elaborate iron light post on a nearby corner. He watches its shadow grow longer and little by little approach him in an ominous fashion. As the shadow is almost reaching the edge of the minimalist bench, the light post is suddenly turned on, and with it a string of identical lights placed at each corner of the boulevard, one after the other.

It is now a building across the boulevard that catches the flâneur's attention. The tall, one-story building has a distinguishing art deco character, its traits so eloquent and refined that it was probably built at the end of the deco period, perhaps the late 1930s. A large parallelepiped with geometric and symmetric ornaments, the building was originally a movie theater. After several conversions, renovations and additions throughout the century, when it housed various businesses, the last one being a contemporary art gallery, it has recently been reconverted to its original function. In order to once again become a movie theater, thorough renovations and detailed restorations have been implemented which, although they are respectful of and integrated into the original architecture, do in the end add a definite contemporary character and finish to the building. Glass panels and window frames, internal details and finishings, it all underlines the period architecture in a clear fashion, yet carries in addition the present spirit and style in an irrefutable way.

It is getting dark outside, the sun has finally hidden itself behind the string of mostly small buildings. Faint sun rays shine through one construction or another. The boulevard is now emptier, a handful of cars or pedestrians move occasionally and rapidly on the streets. It is a cinematic moment—the scenario is perfectly underlit, the streets are bathed in copper, all shadows are dead, time is perfectly still. The flâneur sits on the minimalist stone bench which now grows colder, across the boulevard from the recently renovated art deco building, and scrutinizes the geometry and symmetry of its façade. The traffic lights suddenly shine brighter, and the

corner of his eyes are subsequently lit by red, green and yellow hues in an endless loop. The cinematic moment is brief, and now almost gone. Red, green and yellow; two more red lights, he plans meticulously, and the flâneur will cross the street and walk toward the movie theater.

Under the suggestive title of "XX," the movie theater across the boulevard is playing a carefully organized program to celebrate the turn of the century. Through the theme of nostalgia and the future, an extraordinary selection of passages and excerpts of films and videos from the XXth century have been gathered by a group of foreign film specialists. The program includes major landmarks and little-known or seen works, fiction and documentary films from Hollywood, Europe, Third Cinema, television and cable. The program's poster, a row of which is affixed on the theater's windows, displays a chaotic, urban scenario populated by tall and thin buildings, a few round-shaped ones, and small flying machines of diverse forms and sizes, all depicted in black, white, gray and silver. The flâneur presses his hands against the theater's glass windows, his warm breath leaving a fading circular halo of mist and moist on the clean and transparent surface. There is something deeply melancholic about the program, so full of Modernist naiveté, a mix of fear and hope toward a perfect future. Inside the multiple flying machines and buildings behind the theater's glass windows, the inhabitants of this fabulous and utopian XXth-century futuristic metropolis look busy, healthy and happy.

0 0 : 2 0

What seems like the last breath of winter makes itself strongly felt. The flâneur pushes the building's heavy glass doors which open smoothly and enters the art deco theater in search of comfort and shelter from the evening air, which now feels inexorably cold. The lobby is empty and overlit. The flâneur purchases a ticket and hands it to a sleepy clerk who bows politely to him without uttering a word. He can hear the faint sound of bombs exploding and machine guns firing from inside. As he walks toward the thick black velvet curtains on the far left side of the lobby, he turns his head backwards and catches a glance of the flashing red lights of an ambulance crossing the boulevard at the first hour of the night.

The velvet curtains are not only thick, but heavy. The flâneur pushes them aside and enters the pitch dark screening room at a brief moment when there is nothing being projected. He tries to adjust his gaze in search of the path to a vacant seat. After a couple of cautious steps, the opulent image of the Madonna and her child are projected on the screen revealing a huge and less than half-full auditorium. On his right, a spectator is leaving, and another one gets up in the second row. The flâneur looks for an appropriate seat, considering the angle of vision and his own isolation. He finds one in the penultimate row, no one immediately behind or in front of him, half a dozen seats apart from the next nearby spectator. As the Madonna, an icon of our culture, holds her child in her arms, he sits down and moves his body around in the dark for some time until he finds a comfortable position.

After a sequence of images (a madman screaming, crying and laughing; a man in a tuxedo smoking a cigar; a barefoot woman in a long red dress; a naked man dancing; a naked woman singing; a man sleeping in the back of a car; a bed of red roses; an ocean liner; a volcano in eruption; a dialogue between two Frenchmen on a motorbike; a murder in a back alley), the flâneur concludes that the images follow no obvious concept or design. They have not been arranged in a clearly thematic or chronological pattern. Some of them are quite long in duration, others fairly short; most of them are silent, and the foreign sound has not been subtitled. The fictional is interrupted by the documentary—in fact at times one cannot distinguish one from the other. Images are played in slow, normal and rapid motion, backward and forward, inverted, reversed, slanted and upside down. At times a black screen appears for different lengths of time, bathing the entire room in complete darkness. However, there is an uncanny rhythm to the sequences and juxtapositions, a striking rapport between passion and disaster, politics and sex, fact and fiction, glamour and hunger, the epic and the romantic, the intimate and the public, Hollywood and the other.

Spectators come and go, most of them on their own. The films are both engaging and boring. The flâneur is increasingly absorbed by the spectacle; he is as drawn into the projections as into the dark intervals. Here he finds the magic of the movies, of the black box with wonderful and cruel

00 : 21

images of the world fabulously rendered in pure light. The screened images have caught all his attention, and as the theater becomes emptier, hours seem to pass by as if they were minutes. He sees images of war, long passionate kisses between men and women of all ages, races and sexual preferences, wild and tamed animals in the desert, the jungle, the ocean and the zoo, countless sunsets and sunrises, people, cars and buildings of different periods and origins. There is a long and graphic scene of sex between an Asian couple, a woman running in the dark, a group of youngsters shooting drugs, an eye staring at the camera, a few cartoons, images from television (soap operas, music videos, newscasts, advertisements), many dialogues, a clown, an assassin, a prostitute, a millionaire, a saint. Besides numerous anonymous or unidentified images, the flâneur recognizes bits and pieces of Akerman, Allen, Antonioni, Bergman, Buñuel, Capra, Cavalcanti, Chaplin, Cocteau, Coppola, Costa Gavras, Cronenberg, De Mille, De Sica, Disney, Dreyer, Eisenstein, Fassbinder, Fellini, Figueroa, Ford, Godard, Hawks, Haynes, Herzog, Hitchcock, Huston, Jarmusch, Kazan, Kiarostami, Kubrick, Kurosawa, Lang, Lee, Lelouch, Malle, Marker, Minnelli, Muybridge, Ozu, Pasolini, Renoir, Resnais, Reynaud, Rocha, Rossellini, Scorcese, Scott, Tarantino, Tati, Van Sant, Visconti, Wajda, Waters, Welles, Yimou.

The flâneur begins to feel his eyes, mind and body tire. He repeatedly repositions himself on the seat to find a more comfortable, relaxed position. With his head resting against the edge of the seat, he falls asleep,

only to be woken up by terrorists silently exploding a building in a grainy black-and-white film. Strangely, it is not the noise that awakens him, but the violence of the scene itself that must have contaminated his dreams. The flâneur has his eyes half-shut, and images of an agile tap dancer are followed by butterflies fluttering over a bright field. There is a series of jump cuts and a long steady shot, and he falls into the Proustian condition of being half-asleep and half-awake. The myriad of images and the occasional sounds become part of his dreams, complementing them and playing their own crucial role in the narratives represented on the screen and in his head—a gun shot, a kiss, a dolphin, a monkey, a diver, a skater, a puzzle, a riddle, an argument, a funeral. There is a blazing hot day, pouring rain, and a heavy snowfall. It all evokes peaceful memories of the flâneur's past. He feels tired, bored, thirsty, hungry, in need of the rest room, yet still strangely comfortable.

Suddenly, the opulent image of the Madonna and her child are projected on the screen. Shaken by the uncanniness of the repetition, he immediately stands up. For a few seconds he gazes at the Madonna, an icon of our culture, holding her child in her arms. The following sequence is a familiar one (a madman screaming, crying and laughing; a man in a tuxedo smoking a cigar; a barefoot woman in a long red dress; a naked man dancing; a naked woman singing; a man sleeping in the back of a car; a bed of red roses; an ocean liner; a volcano in eruption; a dialogue between two Frenchmen on a motorbike; a murder in a back alley). The

flâneur finds a faint sign on the back of the theater that reads "EXIT" and walks decisively towards it. There he re-encounters layers of thick, heavy velvet curtains. Having found his way through them, he reaches another large screening room. It is identical to the previous one, but reversed. When he turns to the screen, placed on the other side of the wall of the auditorium he has just left, he sees flipped images of war, long passionate kisses between men and women of all ages, races and sexual preferences, wild and tamed animals in the desert, the jungle, the ocean and the zoo, countless sunsets and sunrises, people, cars and buildings of different periods and origins. The flâneur runs out of the auditorium through thick and heavy velvet curtains and finds himself in an empty and overlit lobby. He can hear the faint sound of bombs exploding and machine guns firing from inside. An ambulance crosses the boulevard on the streets.

Still dazed and hypnotized by the excess and repetition of images and bright lights flashed into his eyes for the past few hours, the flâneur pushes the heavy glass doors which open smoothly and exits the art deco building. The flâneur sees the traffic lights turn red, green and yellow; the light posts turn on one after the other; he sees sharp shadows in the pavement and the architecture. It is one of those rare days when one perceives so distinctly the slow and quiet change of seasons. It is getting dark outside, the sun has finally hidden itself behind the string of mostly small buildings. Faint sun rays shine through one construction or another. The boulevard is now emptier, a handful of cars or pedestrians move occasion-

ally and rapidly on the streets. It is a cinematic moment—the scenario is perfectly underlit, the streets are bathed in copper, all shadows are dead, time is perfectly still. There is a strange quality in the air today.

São Paulo, January 2000

Adriano Pedrosa is an artist, writer and curator. He studied law at the Universidade Estadual do Rio de Janeiro, Fine Art and Critical Writing at the California Institute of the Art, and Comparative Literature at University of California, Los Angeles. He has published in *Artforum* (New York), *Art+Text* (Sydney), *Flash Art* (Milan), *Lapiz* (Madrid), *Poliester* (Mexico City), *Frieze* (London), and *Trans* (New York). He is currently an associate curator at Fundação Bienal de São Paulo. He lives and works in Rio de Janeiro and São Paulo.

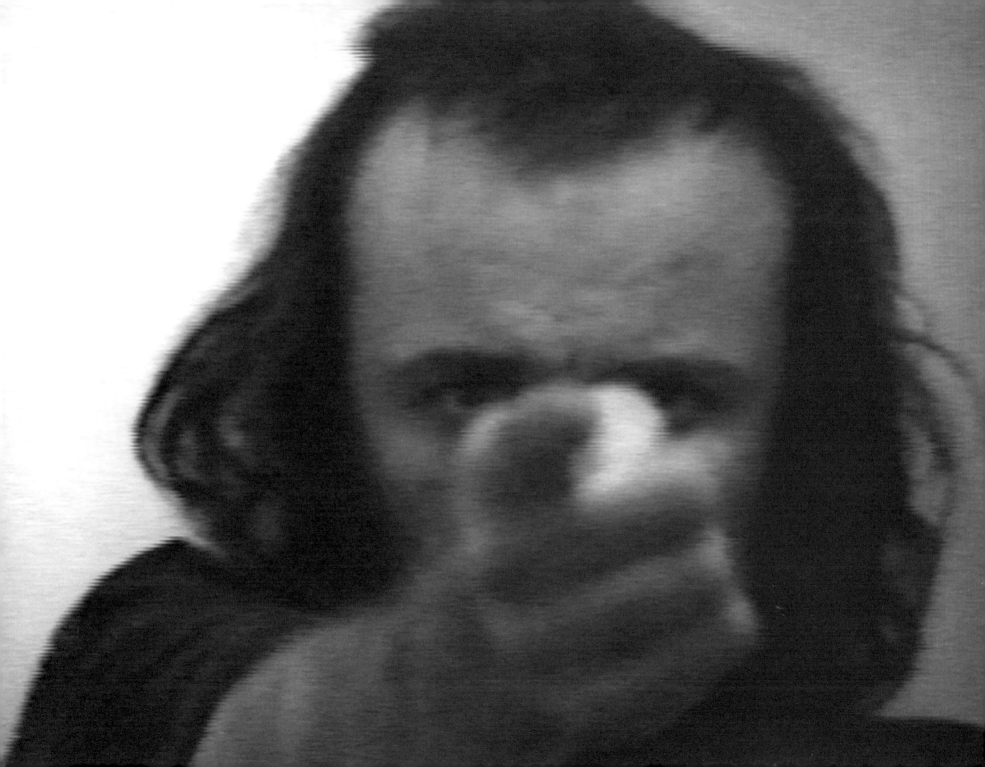

Vito Acconci
Centers, 1971

Vito Acconci has done numerous performance-based works that test the physical possibilities and endurance of the body. Many of his performances were documented in photography, many others in video. While Acconci's repertoire is extensive, he developed an early interest in video, in part because he perceived video to have the power to change the standard artist/viewer relationship.

In *Centers,* Acconci faces the camera, his head and arm in close-up as he points straight ahead at his own image on the video monitor, attempting to keep his finger focused on the exact center of the screen. Acconci is pointing directly at the viewer, as well as pointing directly at himself as he sees his own reflection in the camera. His interest in the psychological dynamic between the artist and viewer is apparent. As the tape proceeds in 22:28 minutes of real time, the only changes in the performance action are slight adjustments in the position of his finger as his physical endurance falters.

Centers is an examination of two of video's essential properties: intimacy and real time. Intimacy is evidenced in the artist's desire to challenge boundaries of public and private. While video editing equipment was scarce in the early 1970s, Acconci seems to have shot this work in real time as "a defiant reaction to the fragmented, incomplete views offered by television. […] The real-time quality of many of [his] videotapes was a technological property that was exploited for aesthetic intent."[1]

C O : 2 5

1. Marita Sturken, "Paradox in the Evolution of an Art Form," in *Illuminating Video: An Essential Guide to Video Art,* eds Doug Hall & Sally Jo Fifer, (New York: Aperture,1990), p. 118.

Vito Acconci
Centers, 1971
single channel video, black & white, sound
22:28 minutes

Darren Almond

Time and Time Again, 1998

A projection of the artist's London studio highlights a specific corner where his quiet, tidy desk at a window overlooks an unremarkable side street. The artist is absent, and the studio appears empty. The only visible change in the projection is that over time, slowly and subtly, the sun sets and the studio is darkened. Installed next to the projection is an oversized, first-generation digital-style flip-clock with numbers in white Helvetica type against a black background. The clock looks efficient and industrial, albeit a little imposing as the minutes pass, and time literally looms over the viewer. A jarring noise, similar to a guillotine falling, sounds as each new minute begins. Time is measured as much visually as aurally. The present clock is the only sign of the artist's absence in the projected studio.

In *Time and Time Again*, Almond distinguishes between "real time" and "actual time." Real time is the projection that we see of the studio, the inconspicuous elapsing of time as the room slowly darkens. Actual time is the viewer standing in the present watching and listening as minutes of life tick by.

Sound plays a critical role in sorting out time from space. The projection, which is silent, allows the viewer to slip into a daydreamy silent space and focus on an internal sense of time. How long a viewer might stay with the projected image depends on how long he or she can focus on something static, which is dependent on the viewer's capacity for meditation, or for lapsing into an interior space of time. The cacophonous sound jars the viewer from imaginary space into present space.

00:27

Darren Almond
Time and Time Again, 1998
video projection with sound and clock
continuous loop

Courtesy Jay Jopling/White Cube, London

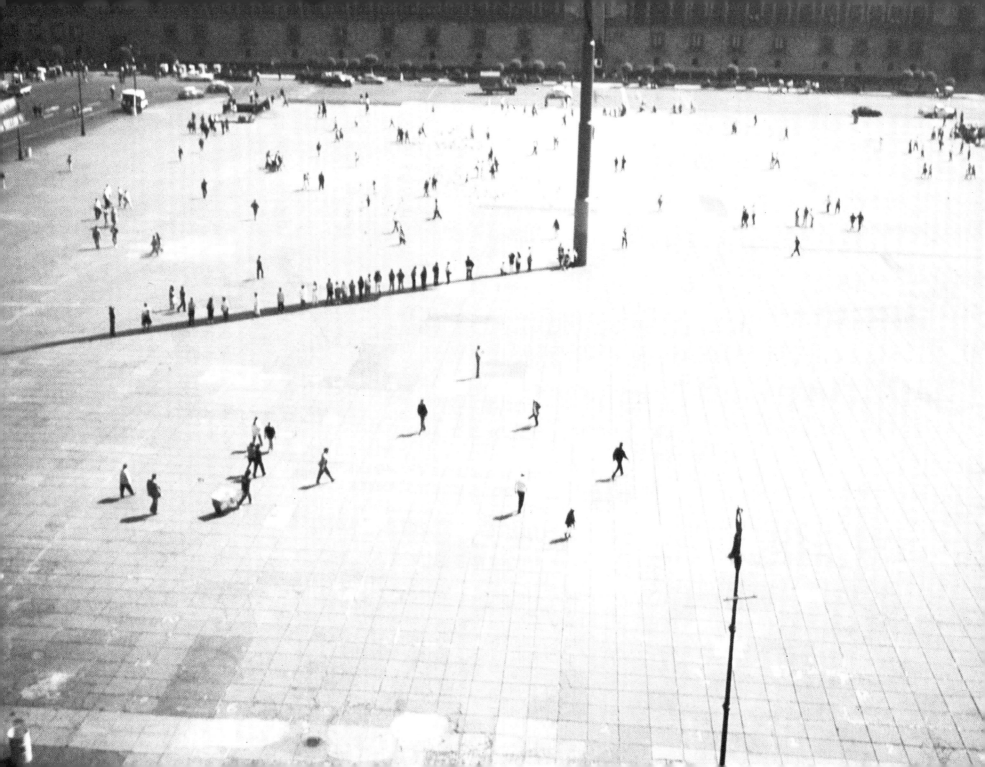

Francis Alÿs
(in collaboration with Rafael Ortega)
Zócalo, 1999

Zócalo is a 12-hour documentary following the progression of the shadow of a flagpole in the main square, or Zócalo, in Mexico City for the course of a day. The Zócalo is perhaps Mexico's most important national site. It was built originally by the Spaniards in the 16th century using the stones from the ruined El Templo Mayor, where the last Aztec emperor Montezuma lived. Bordering it are the Palacio Nacional, where the Mexican president's offices are housed, and the largest cathedral in Mexico (also built by the Spaniards). It was redesigned in 1910, at the beginning of the Mexican revolutionary era, as a site for government spectacles, public gatherings and protest marches. In the center flies an enormous Mexican flag.

"I spend a lot of time walking around the city. […] The initial concept and elaboration of a project generally happen during the walking time. My position as an artist is one of an itinerant – constantly trying to situate myself in a moving environment." [1] A latter day *flâneur,* Alÿs made *Zócalo* based on two temporal events: a walk and a day.

A day in real time, focused on the flagpole at the heart of Mexican national spirit, bears a noteworthy relationship to Andy Warhol's *Empire*. When Warhol said "The Empire State Building is a star!" he meant it had iconographic status as an emblem of New York and America, in the same way the Zócalo of Mexico City is a powerful symbol of Mexican national identity. [2] Duration (eight hours, twelve hours) cannot make an icon, but fixing on it for a significant amount of time can certainly reinforce it.

1. Francis Alÿs, cited in the artist biographies in *Longing and Belonging From Far Away and Nearby*, SITE Santa Fe exhibition catalogue, (Santa Fe, New Mexico: 1995), p. 184.
2. Andy Warhol cited in Russell Ferguson, "Beautiful Moments," in *Hall of Mirrors: Art and Film Since 1945* (Los Angeles: Museum of Contemporary Art/Monacelli Press, 1996), p. 176.

00 : 29

Francis Alÿs
Zócalo, 1999
DVD projection
12 hours

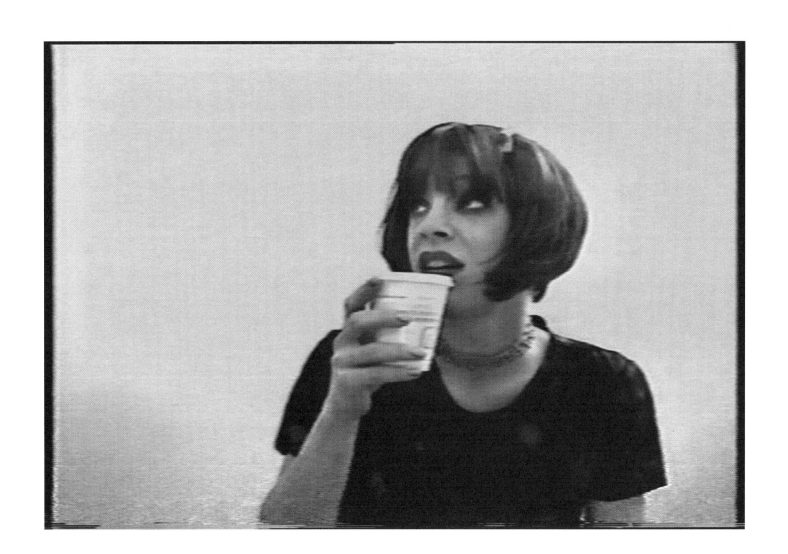

Alex Bag
Untitled (Fall 95), 1995
VHS
57:00 minutes

Alex Bag
Untitled (Fall 95), 1995

In 1976, the critic Rosalind Krauss wrote that an artist's desire to set up a camera and perform in the space before it, thereby using the monitor as a mirror, made video as a medium inherently narcissistic. "Video's real medium is a psychological situation, the terms of which are to withdraw attention from an external object – an Other – and invest it in the Self." [1] From today's cultural vantage point, she was extolling the virtues of Alex Bag's work.

Four years at the School of Visual Arts in New York are played out in 57 minutes. In *Untitled (Fall '95)*, Bag, at the time an art student, "plays" Bag the art student. Sitting alone in a room, Bag talks to the camera as her semi-fictional self, while real-time sounds of the city outside her window bleed into the work. In a series of deadpan, hysterically funny performances mirroring conventions of both a TV serial and a talk show, Bag presents eight diary-like vignettes based on eight semesters of her undergraduate education. Like the work of Shigeko Kubota, who pioneered the notion of the video diary as a way of marking time, Bag plays upon video's inherent intimacy and immediacy to tell her story.

Interspersed between her monologues of each semester's tales are eight set pieces in which Bag performs scenes from the background noise of her imagination. Perhaps the most telling is her spoof on the real-time property of video. In her parody of a pretentious visiting artist, Bag presents a video project entitled *Purse*, where she leaves a video camera on in her purse every day for seven hours for one year. In an equally hilarious scene on the conventions of moving image technology, the pop singer Björk explains how television works and the central role it plays in her life.

Within a conventional condensing of a narrative, Bag manages to interject scenes that both elucidate and parody video's capacity to be intimate and to comment in real time.

1. Rosalind Krauss, "Video: The Aesthetics of Narcissism," *October*, #1, Spring 1976, p. 57.

00 : 3 1

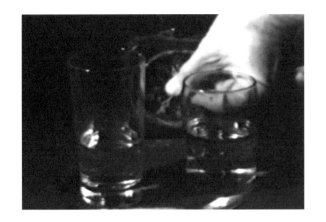 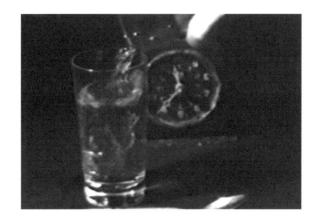 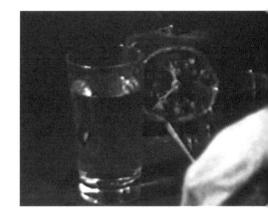

John Baldessari
Four Minutes of Trying to Tune Two Glasses (for The Phil Glass Sextet), 1976
single channel video, black & white
4:09 minutes

Courtesy Electronic Arts Intermix, New York

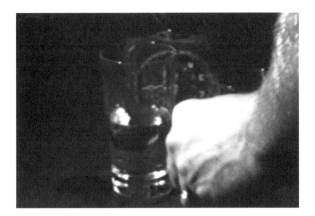

John Baldessari

Four Minutes of Trying to Tune Two Glasses (for The Phil Glass Sextet), 1976

Renowned for his sense of wit and interest in visual puns, John Baldessari uses video and time to engage the lighter side of cinematic formalities and the process of experimental musical composition.

Playing with absurdity and random attempts at making melodic sounds, Baldessari investigates the manipulation of time in this short, 4:09 minute video. The artist's hands appear before two glasses of water, with an alarm clock set at twenty minutes to twelve. With a small mallet, he attempts to "tune" two glasses of water, by pouring more or less water into each glass to alter their respective pitches. The parenthetical subtitle refers to the musical compositions of Phillip Glass, famous for their subtle tonal and rhythmic variations. The clock ticks audibly, as if he is in a race against it. His tuning efforts become more clumsy and hurried as the clock nears twelve, until finally the alarm sounds. Although the real time of his tuning activity is just over four minutes, the ticking clock indicates that twenty minutes of screen time have passed. Baldessari is exploiting the cinematic convention that one's perception of time seems shorter when action is intensified. Phillip Glass's work is influenced by musical traditions in India and other parts of the Far East. As Baldessari competes against the clock to tune two glasses of water, an 'East versus West' pun is articulated: Glass's Eastern influence of meditation and Zen is juxtaposed with Baldessari's Western race against time.

DOCUMENT

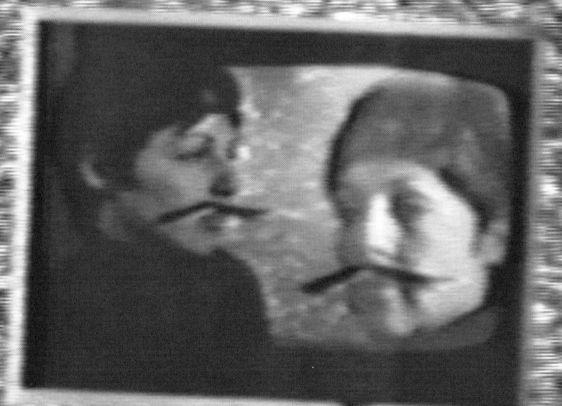

Copyright © 1983

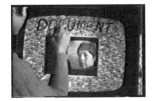

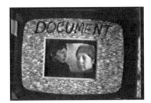

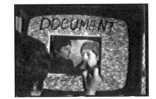

Lynda Benglis
Document, 1972

In the early 1970s, video documentation and video art were not seen as different disciplines.[1] A video made as a record of a real-time performance or "happening" had the same chance as a tightly edited, scripted work of entering the discourse as art. Benglis' *Document* explores the narrow territory between documentation and art. Art had traditionally relied upon painting and then photography to capture and record important moments. In the early 1970s, with the advent of video, artists were exploring what the capacities of video might be vis-à-vis the other visual art disciplines. Here, Benglis tests video's potential by trying it out on the tradition of the self-portrait in art.

In *Document,* Benglis stands in front of a still photo of herself, which is in turn taped to a video monitor bearing a recorded image of her. Which one is the original? The artist herself? The photograph of her? Her recorded image on the video monitor? Or the real-time video of all of this in the making? Portraiture is perhaps one of the most important genres in painting and photography. Asserting that video is a medium with an inherent capacity for infinite mechanical reproduction, Benglis asks the viewer to reconsider the notion of the "original" and the "authentic" in art.[2] Art history has depended upon unique, "permanent" objects to define the past and carry the discourse of cultural representation forward. *Document* is an early attempt to see if the easily replicated moving image could achieve the same goal, while subtly referring to the history of art as a guidepost.

00 : 35

1. Ann-Sargent Wooster, *The First Generation: Woman and Video,* 1970-75, (New York: Independent Curators Incorporated, 1993), p. 42.
2. Walter Benjamin, "The Work of Art in the Age of Mechanical Reproduction" [1936], in *Illuminations,* ed. Hannah Arendt, (New York: Schocken Books, 1969).

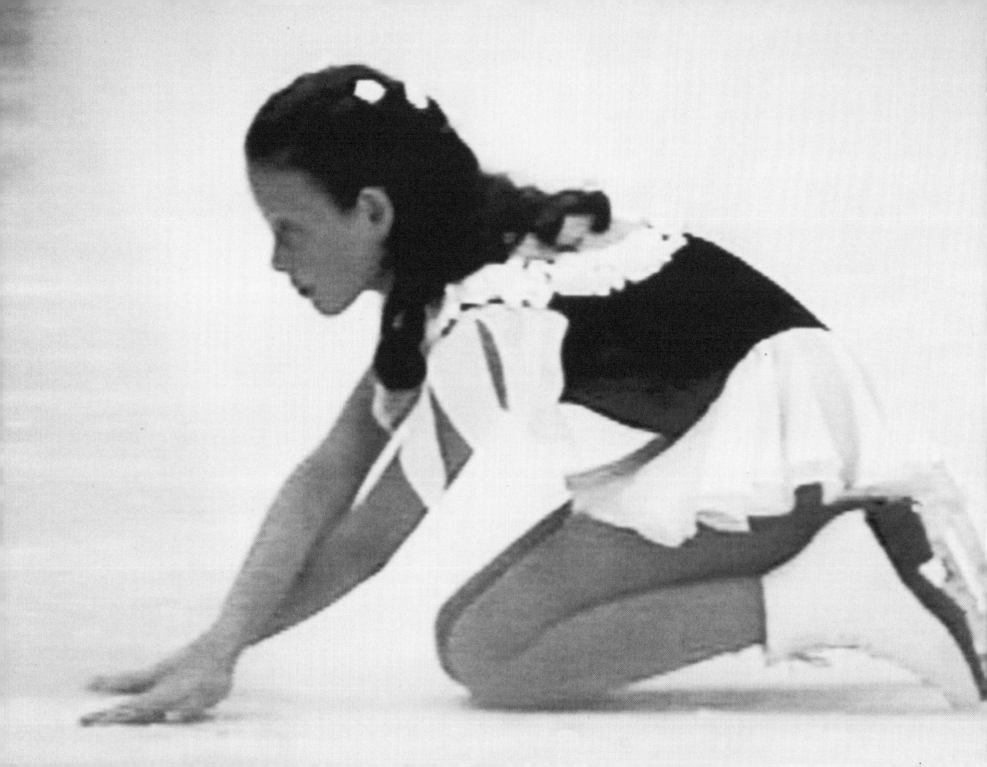

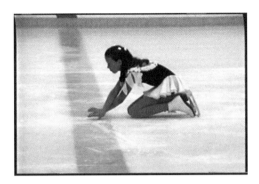

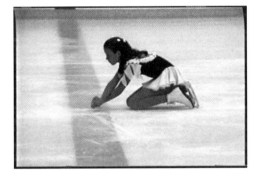

Andrea Bowers
Waiting, 1999

A young woman in ice skates and a glittery figure skating dress appears carefully positioned on the ice, waiting for her music and routine to begin. Kneeling on the ice, her hands before her, she breathes shallow breaths as she anticipates her music to begin. Her hands are lined up on the rink's blue line, with the red line border in the background. The frilly, embellished young woman is exquisitely framed in a cool, minimal, abstract composition. Andrea Bowers has presented us with a document of a moment that is at once frozen and expectant. The skater is so perfectly still; it is as if she is a still image. What jerks us out of this rapt, motionless state is a sign of the physical discomfort. The skater lifts her cold hands off the ice and makes fists in an attempt to warm them, then places them back on the ice again. This 45-second episode repeats endlessly.

In the sparest of gestures, Bowers has illustrated video's ability to hold viewers' attention by keeping them in anticipation. Using devices such as commercial breaks, future episodes and laugh tracks, television has trained viewers to wait and see what happens. While *Waiting's* focus is on a moment to which television would never give attention, the experience of anticipation is one the viewer expects when approaching the moving image. Repeating the same element over and over again forces a reconsideration of the perception we have of a work of art and the "value" that it has been assigned. Does replication add or subtract value from one's primary experience of video? In addition, because physical experiences that are repeated are often associated with ritual (such as chanting, prayer or physical activity), *Waiting* links our perception of motion with our sense of time.

00:37

Andrea Bowers
Waiting, 1999
laserdisc, laserdisc player, video projector,
metal bracket, plexiglass
continuous loop

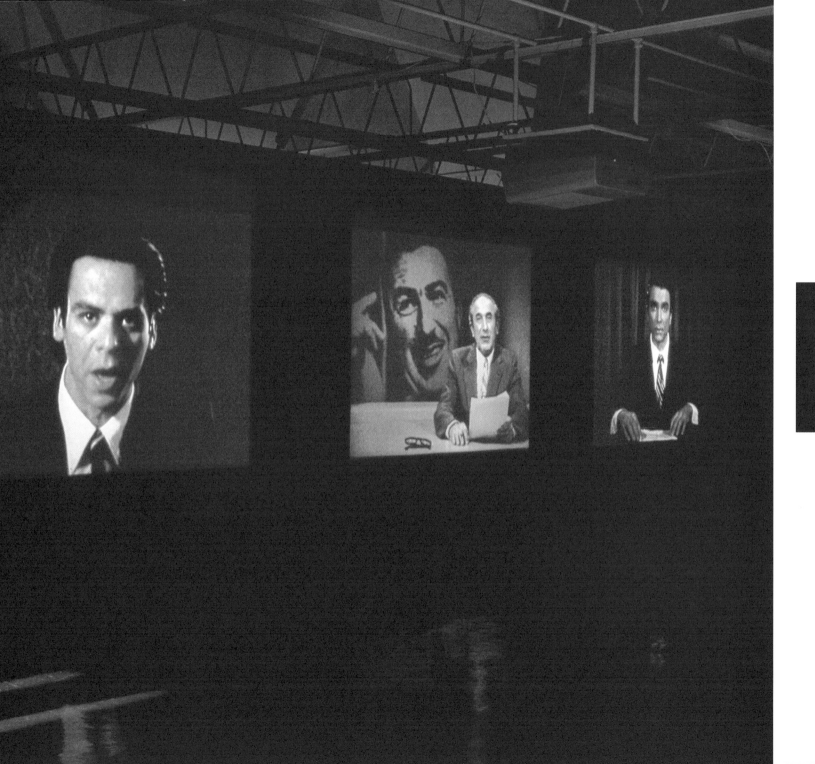

Stan Douglas
Evening, 1994

Stan Douglas is a Canadian artist whose works often address historical events, and "moments when history could have gone one way or another."[1] While Douglas's work springs from actual historical references – European settlers coming to the New World, abandoned Utopian towns, a 1960s jazz ensemble celebrating black American genius – there is a sense that the artist is most concerned with suspending these historical references in time. He generally takes the viewer to the precise moment when one begins to understand the larger picture.

Evening consists of three projected images of American television evening newscasts, running simultaneously side by side. Through archival research, Douglas gathered footage from three Chicago network stations from 1969 and 1970, when broadcasters began to adopt a presentation of the news in a format called 'Happy Talk News' – no matter how bad the news, say it with a happy face. Meshing the editorial with the theatrical resulted in the presentation of serious matters in a glib, trivialized fashion. The Vietnam War, the trial of the Chicago Seven, the investigation into the murder of a Black Panther are all covered with lilts and smiles. Each of the projections represents a station's news; they can be heard independently when standing directly in front of one, or simultaneously when standing far away. When viewed from a distance *Evening* induces psychological anxiety as sounds become indistinct, with the exception of key buzz words – "murderer," "My Lai massacre," "Communists."

00:39

Douglas has created a visually compelling image and sound collage, which parodies the accepted structures of television and journalism. But more than this, he has made a work that asks the viewer to consider the way we receive and digest epic events in accelerated, condensed time. As Douglas states, "We live in the residue of such [historical] moments, and for better or worse their potential is not spent yet."[2]

1. Diana Thater, "Interview with Stan Douglas," in *Stan Douglas* (London: Phaidon Press, 1998), p. 29.
2. Ibid.

Stan Douglas
Evening, 1994
video installation
14:52 minutes/each rotation

Courtesy David Zwirner Gallery, New York

Fischli/Weiss
The Way Things Go, 1987
color film
30:00 minutes

Courtesy Matthew Marks Gallery, New York

Fischli/Weiss

Der Lauf der Dinge (The Way Things Go), 1987

Since the late 1970s, Swiss artists Peter Fischli and David Weiss have captivated audiences with their fascination with the hidden wonders of everyday life. Through their work, the artists explore the relationship between opposites such as work and play, and order and chaos. Their interest in the spectacle of the ordinary is sublime. One of their pieces (for their 1997 solo exhibition at the San Francisco Museum of Modern Art) contains over eighty hours of videotape whose subjects include a chef at a Swiss restaurant, the annual Zurich moto-cross race, and workers from the sanitation department.

Fischli and Weiss's acclaimed 1987 film, *Der Lauf der Dinge (The Way Things Go)*, follows a seemingly unpredictable domino effect of a series of simple objects such as rope, soap, Styrofoam cups, old shoes, balloons, tea kettles, and mattresses. Inside a large warehouse, the artists built a fragile but monumental structure out of these common household objects. When a succession of these items are set off with fire, gas, and gravity, and general Chemistry 101, they activate a sensational chain reaction of exquisitely crafted chaos. Sequencing and narrative go hand in hand as cinematic conventions, but Fischli and Weiss manage to separate the two, favoring sequencing and timing. Since the objects are set up to have a domino effect but rely on time, rather than a story line, to dictate their next move, the entire work can be viewed as a kind of timepiece or clock. *Der Lauf der Dinge (The Way Things Go)* consists of its own, self-contained, impenetrable organization that continues to tick without regard for the world around it.

00:41

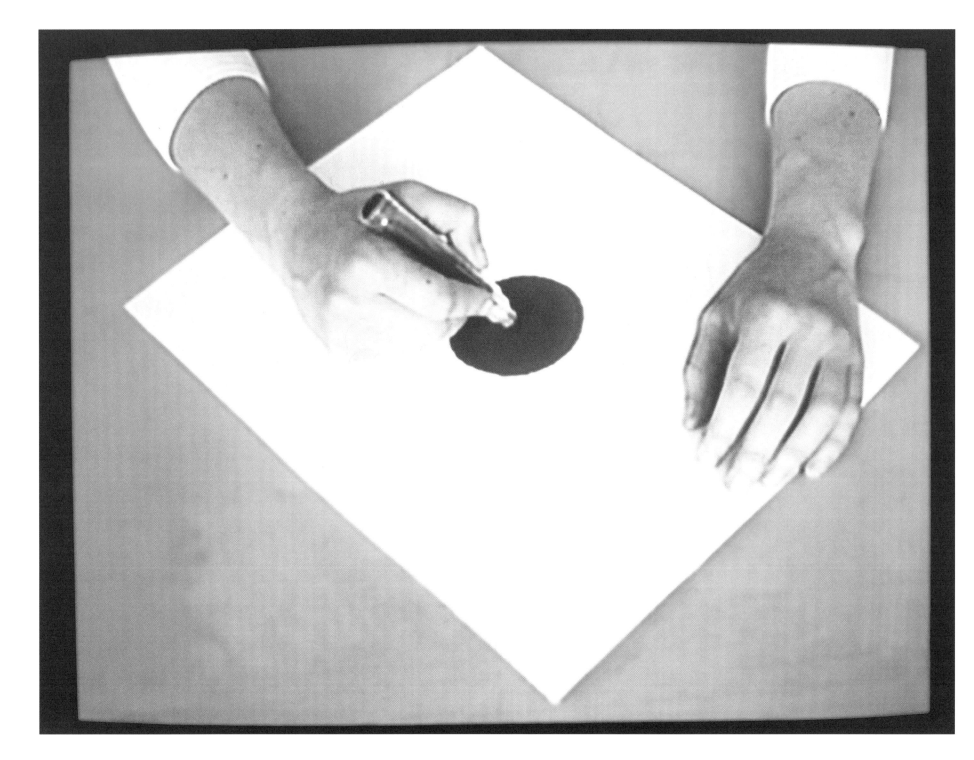

Ceal Floyer
Ink on Paper (video), 1999

A hand, a felt tip marker pen, a white sheet of paper, time. Ceal Floyer's *Ink on Paper (video)* is a one-hour 55-minute tale of a marker pen bleeding to death. It is an epic and heroic performance – the hand of the artist appears motionless as it presses the tip of the pen onto a white sheet of paper. The work appears on a monitor and seems remarkably like a still image. Very little change occurs in the work if watched too closely. To see the pen die one must visit the piece at intervals, say, every ten minutes or so.

In the way that many video installations embody the formal elements of sculpture, *Ink on Paper (video)* exists as a video, a drawing and a performance all in one. As a drawing, the irregular, flat, black blob that Floyer makes is most closely related to the materiality and presence (as Carl Andre insisted, the "now") inherent in Minimalist works from the 1960s. As a performance, the piece shares a relationship with the brand of performance that attempted to make art using the endurance of the body as a vehicle, such as Paul McCarthy's *Painting a White Line with My Face* (1970). In all of these art forms, it is the physicality of real time (not the much-admired "misty" time found in condensed narratives) that is the principal subject matter.

00 : 4 3

Ceal Floyer
Ink on Paper (video), 1999
VHS videotape
1 hour 55 minutes

Courtesy Lisson Gallery, London

Dara Friedman

Total, 1998
Government Cut, 1998

A fantastic scene of destruction is played out in a cheap hotel room. A young woman (the artist herself) purges herself of wild rage by ripping apart the contents of the room. Using all her limbs, she stomps, throws, kicks and flails. Once the room is adequately leveled, a reversal of the actions takes place through a cinematic sleight of hand and the room is miraculously reconstructed. Never has decimation looked so elegantly choreographed. There are moments when Friedman's arms are spread like wings as if she might take off in flight. At one point she jumps up and down on a table, pounding out staccato rhythms. The corresponding sound is jarring and disturbing because it is also reversed, and the viewer must reverse his or her perception of that action.

In *Total,* Friedman has turned cinematic narrative structure on its head. While we expect the meaning of a narrative to come together at the end, *Total's* true meaning only becomes clear in the middle, when destruction morphs into reconstruction. The piece disputes the inherent linearity and sequencing of time.

Friedman's interest in subverting linear notions of time (and her interest in the film projector as a sculptural presence) tie her to the Argentinean conceptual artist David Lamelas.[1] In his films and projects, Lamelas concerns himself with the destruction and subsequent liberation of linear time. In addition,

Friedman's work, like Lamelas', seem as much about the time a viewer spends watching it, as about the moving images at hand. This is particularly the case with Friedman's *Government Cut.*

In the kind of slow motion that creates the sensation of floating, young bodies of all shapes and sizes jump off a pier into bright blue waters in a continuous loop. Some are fearful, others are bold about their "leap into the void," but unlike Yves Klein's famous photograph from 1960, this is clearly not a montage but a real event. *Government Cut,* as Friedman has stated, "functions like a fountain that is constantly in motion."[2] While Klein's precedent is heroic, Friedman's is decidedly anti-heroic. His is about the pretense of how it ought to be remembered, while hers is about leaving the viewer with the memory of how it might have felt to make the leap.

1. For further information on his work, see *David Lamelas: A New Refutation of Time,* the catalogue for his 1997 retrospective at the Witte de With in Holland.
2. In conversation with the artist, October 16, 1999.

00:45

Gilbert & George
The Singing Sculpture, 1971-91
color film (by Phillip Haas)
22:28 minutes

Courtesy Sonnabend Gallery, New York

Gilbert & George
The Singing Sculpture, 1971-91

In the late 1960s the British collaborative duo, Gilbert & George, declared themselves not merely artists but "living sculptures." What this meant is that they would not make sculptures, but rather, they would exist as a sculptural entity which had taken form. They would seek to be interchangeable and abolish all high meaning from their work. Artist and artwork were now one and the same. Like a sculpture, they would hold themselves rigid. In a text they prepared in 1970 about their piece, *A Magazine Sculpture,* they stated: "We are only human sculptors in that we get up everyday, walking sometimes, reading rarely, eating often…being natural…tea drinking…dying very slowly, laughing nervously, greeting politely, and waiting till the day breaks."[1]

In January 1969 in London, Gilbert & George made their first public appearance as a living sculpture. They started to sing, and thus began calling themselves *The Singing Sculpture.* They continued these living sculptural presentations around Europe and America until 1973. They performed not just in museums and galleries, but in public concerts and nightclubs. They would perform with minimal props – a walking stick, a glove, and a recording of the maudlin song, "Underneath the Arches." Gilbert & George scholar Wolf Jahn puts forth the idea that these props symbolize deeper ideas in their work. The gloves represent their interchangeability, and the stick, "as an allusion to walking, stands for the (unending) time component of the act: marking time, endless stasis, eternal monotony."[2]

As a film (this version was a re-staging of their earlier performances in honor of the twentieth anniversary of the Sonnabend Gallery), it serves as a document of the artists' engagement with time. The film allows the viewer to actually experience their state of "living sculpture." Gilbert & George's *The Singing Sculpture* came about in the late 1960s when Minimalism was the dominant force in the art world, particularly in sculpture. Monolithic and unchanging, Minimalist works sought timelessness. For Gilbert & George to create their "living sculpture" contemporaneous to Minimalism was their attempt at immortalization and stopping time.

1. Wolf Jahn, *The Art of Gilbert & George* (New York: Thames and Hudson, 1989), p. 21.
2. Ibid., p. 75.

Douglas Gordon
Bootleg (Empire), 1997

In a dark, seemingly airless room, a grainy film projection of a familiar architectural icon glows in white light against the backdrop of nighttime. The camera stays on the luminous Empire State Building, while taking in all that is happening in the room around it. People walk past the projected image from time to time. They appear in color, the projected image in black and white. They are living, moving, and present; the Empire State Building is inert, heroic and historical. Warhol's *Empire* is intended for projection; Gordon's for a monitor. Why? Perhaps because a bootleg of anything is never in the same form as the source. Gordon's *Bootleg* is in effect, a remake of Warhol's original. "The phenomenon of the remake implies the development of *processes of anamnesis*, the dredging up of buried events and of 'things forgotten in the beginning': a development likely to keep reviving and renewing future modes of appropriation." [1] The original *Empire* was shot in film (thus projected), and *Bootleg (Empire)* was made in video (thus, its seminal connection to a television monitor).

Surreptitiously borrowing Andy Warhol's famous 1964, eight-hour film *Empire* for *Bootleg (Empire)*, Gordon at once historicizes and reveres *Empire* by making it the primary subject of his two-hour video. Simultaneously, by capturing *Empire* in its museological setting with viewers coming and going, Gordon further elongates the experience of Warhol's original by layering real time on top of real time.

1. Jean-Christophe Royoux, "Remaking Cinema," in *Cinema Cinema: Contemporary Art and the Cinematic Experience* (Eindhoven & Rotterdam: Stedelijk Van Abbemuseum & NAI Publishers, 1999), p. 23.

Douglas Gordon
Bootleg (Empire), 1997
VHS videotape
continuous loop

Courtesy Gagosian Gallery, New York

Douglas Gordon
Monument to X, 1998
video projection
14:00 minutes

Courtesy Gagosian Gallery, New York

Monument to X, 1998

Shifting perceptions, creating new contexts for the moving image, and revealing the normality of voyeurism – these are all strategies employed in the work of Douglas Gordon. "I like to take a detail and allow it the time and space to become epic, or a monolith in its own right."[1] In *Monument to X*, Gordon focuses on what might be all of cinema's most conventional moment of drama: the kiss. For 14 minutes, viewers are subjected to a tender, loin-stirring kiss by a young man and young women in what appears to be a park or a garden. Famous for his slow-motion treatments of cinema such as *24 Hour Psycho* (1993), his 24-hour long version of Hitchcock's *Psycho*, Gordon forces the viewer into an intensely voyeuristic moment because the mechanics of every physical gesture is made epic by time. Because of the duration of many of Gordon's films, getting to "the end" never matters.[2] Like many of his works, *Monument to X* is both visually arresting and difficult to watch from start to finish. While the time it takes to see his work is often a factor, this is a relatively short work in his oeuvre. "Either I am asking people to give it time, or I'm giving people time out from something else instead."[3] If it is possible to detach from one's own self-conscious voyeurism while viewing this work, each gesture – every turn of the head, each time the man's hand touches the woman's face, their joined faces glowing in oneness – can be read as a visual image entirely detached from the sequencing and narrative of the kiss. Every tiny nuance is made monumental by the time it is given.

1. Jan Bebbaut, "Interview with Douglas Gordon," in *Kidnapping* (Eindhoven: Stedelijk Van Abbemuseum, 1998), p. 17.
2. Jean-Christophe Royoux, "Remaking Cinema," in *Cinéma Cinéma: Contemporary Art and the Cinematic Experience* (Eindhoven & Rotterdam: Stedelijk Van Abbemuseum & NAI Publishers, 1999), p. 21.
3. Jan Bebbaut, "Interview with Douglas Gordon," in *Kidnapping* (Eindhoven: Stedelijk Van Abbemuseum, 1998), p. 182.

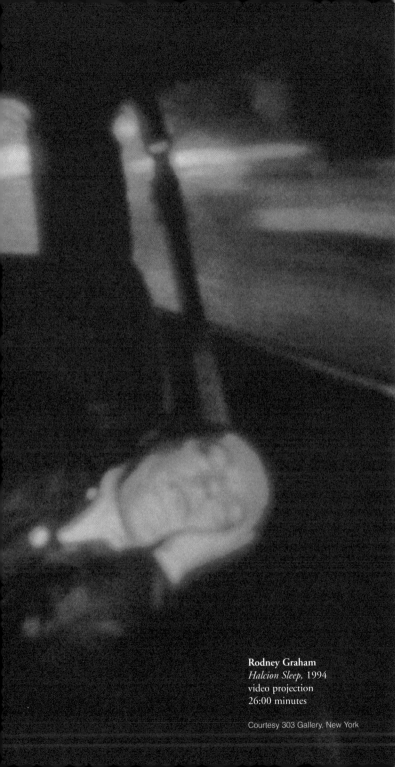

Rodney Graham
Halcion Sleep, 1994

One the night of October 25, 1994, I went to sleep in a rented room in a motel on the out-skirts of Vancouver after taking 0.5 mg of a sedative whose brand name – Halcion – evokes peaceful memories of the past. Later that same night I was moved by my brother and a friend to a waiting car. I was driven, as I slept, to my apartment in the centre of the city and put into my own bed, where I slept until morning.

Thus begins *Halcion Sleep*, Graham's tribute to Sigmund Freud and Rip Van Winkle. This 26-minute continuous loop was shot in a single take. The only "action" is the artist's silent, sleeping body, bobbing blissfully in striped pajamas, as the car, having come from nowhere in particular and going nowhere in particular, travels around the streets of his native Vancouver. The viewer is given neither images of the dead weight of the body as it is carried in and out of the car, nor images of Graham dozing off in the motel room. We are left only to imagine them.

From Graham's text in the beginning, the viewer knows, perhaps with envy, that the artist is sleeping while enjoying a flurry of dreams recalling pleasant memories of his past. Unlike Andy Warhol's 1963 film *Sleep*, where the viewer is treated to John Giorno having an endless sleep, we know that Graham, thanks to Halcion, is engaged in the allegorical passage from childhood to adulthood and back to childhood. Intellectually, the viewer can imagine Graham on a spiritual journey toward oneness with the self. Visually, however, it is just real time. And since we lack a concept of Zen in the West, real time is all we have.

0 0 : 5 1

Rodney Graham
Halcion Sleep, 1994
video projection
26:00 minutes

Courtesy 303 Gallery, New York

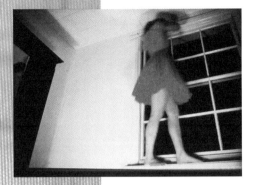

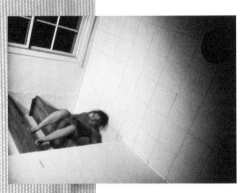

Lucy Gunning
Climbing Around My Room, 1993
VHS videotape
8:00 minutes

Courtesy Greene Naftali, New York

Lucy Gunning
The Headstand, 1995
VHS videotape
6:00 minutes

Courtesy Greene Naftali, New York

Lucy Gunning

The Headstand, 1995
Climbing Around My Room, 1993

Practitioners of yoga have long held that the headstand is one of the essential postures for calming the body, refreshing the blood in the lower cavities, and relieving the organs in their struggle against gravity. Lucy Gunning's *The Headstand* shows the artist cautiously executing a headstand, holding the pose as long as she can until she tumbles down, and then kicking back up again. Challenging gravity, the work is presented with her body inverted, causing the viewer to wonder if she is hanging from the ceiling.

Climbing Around My Room records a similar feat of physical endurance. This time a young woman in a frilly red party dress scales the walls vertically and moves about the room without once touching the floor. Exhibiting primate-like grasping abilities, she moves from bookshelf to commode to radiator to door jam, and so on. Like *The Headstand*, the mental and physical concentration that the climber brings to this task is extraordinary. Similar to *Climbing Around My Room* is Bruce Nauman's video *Walking in an Exaggerated Manner Around the Perimeter of a Square* (1967-68), though Gunning's results of solitary hours in the artist's studio are more poetic and less tedious than Nauman's.[1] These two works by Gunning also recall Carolee Schneemann's famous performance and video *Up to and Including Her Limits* (1973-76). This work consists of a video playback of Schneemann suspended upside down in harness while she draws across a vast floor surface. Like Gunning, she does away with props in favor of a focus on the artist's body alone, against her physical limits, the universe and real time.

Gunning's works seem like rituals. A ritual is "determined by the lack of a goal and time of the ritual, which doesn't measure time, but marks it."[2] Both works have a relationship with an object or a particular placement. *Climbing Around My Room* is projected on a crooked shelf and *The Headstand* in the upper corner of a room, and in this way Gunning brings together the territory of video with the temporal ideas of Minimalist sculpture.

00 : 53

1. Gilda Williams, *"Profile: The Animal Bride," Art Monthly*, #200, October 1996, p. 49.
2. Denise Robinson, "Where Was I?," exhibition catalogue for *Chapter* (Cardiff, Wales) p. 7.

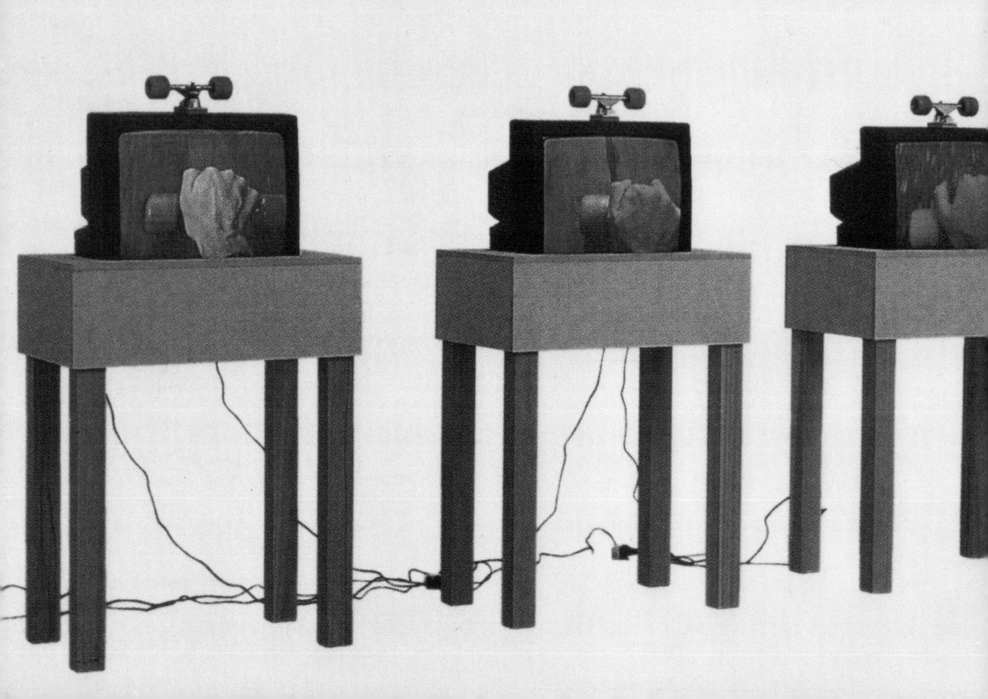

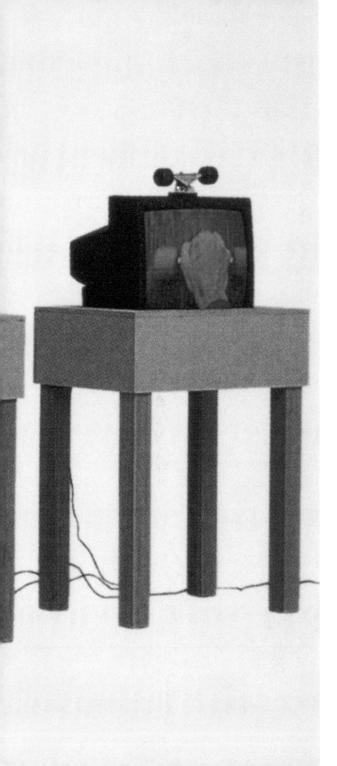

José Antonio Hernández-Diez
Indy, 1995

Parts of skateboards protrude from the top of four monitors mounted onto wooden pedestals with cords dangling below. On each of the four monitors, a hand is seen pushing the wheels of a skateboard along a straight section of uninterrupted pavement. Visually and audibly, the moment of "action" is the contact point of the wheels of a skateboard on pavement. Each of them is different – we know this only from the grain of the pavement, the slightly different noises generated, and the slightly varying positions of the hands on the wheels.

Hernández-Diez manages to freeze a moment of time while keeping the image moving. There is no action, just the constancy of noise, the certainty that the piece is with you. Like the sound a child makes to emulate a speeding car, *Indy* shares a similar audible presence. The hand and the skateboard are surely moving, somewhere, maybe, but one is never sure exactly where to. Like a shark or an eight-track tape, the hands and skateboards seem to move only forward, occupying the same linear trajectory as time.

00:55

José Antonio Hernández-Diez
Indy, 1995
four VHS videotapes, four monitors,
wood pedestals, skateboards
continuous loop

Collection Isabella Prata & Idel Arcuschin, São Paulo

Gary Hill
Around & About, 1980
single channel video, color
5:00 minutes

Courtesy Electronic Arts Intermix, New York

Gary Hill
Around & About, 1980

The experience of language and the sensorial dissonance between seeing images and hearing sounds are primary occupations in the work of Gary Hill. In his pivotal work from 1980, *Around & About*, Hill explores the boundaries of oral comprehension and visual experience by conflating language and image. Flashing images of mundane interiors and closed portals are seen together with a monologue that is at once intimate and vague. ("There's time involved here and it's yours as much as mine. [...] I am sure it could have gone another way. [...] If you want to leave, you can do that or just turn off."). By speaking to the viewer directly in the first person and in the present tense, and by linking each syllable to an image, Hill pioneered two strategies that appear again and again in his work. "The thing about *Around & About* is that I was able to use the image and the text as a single unit. Suddenly I began to think about how far the images could get from what I was saying and still have the tape work." [1] Elsewhere Hill states, "Every syllable is tied to an image: suddenly words seemed quite spatial and the viewer becomes conscious of a single word's time. [...] Time [...] is central to video." [2]

Around & About challenges the viewers' consciousness by focusing on the awkward space between the moment we see or hear something, and the moment we comprehend what we have seen or heard. Hill writes, "A kind of 'organic automation' occurs as the speech pushes the images out and on and off the screen. One's sense of time in relation to images and language becomes highly manipulated." [3]

00 : 57

1. Lucinda Furlong, "A Manner of Speaking: An interview with Gary Hill," in *Afterimage*, Vol. 10, No.8, March 1983, p. 12.
2. Gary Hill, "Inter-view," in *Gary Hill* (Amsterdam & Vienna, Stedelijk Museum & Vienna Kunsthalle, 1993-94) p. 13.
3. Gary Hill, "And If the Right Hand Did Not Know What the Left Hand Is Doing," in *Illuminating Video: An Essential Guide to Video Art*, eds. Doug Hall & Sally Jo Fifer, (New York: Aperture, 1990), p. 93.

Jonathan Horowitz
The Body Song, 1997

Michael Jackson's testimony to his ecological ethics is his track "The Earth Song" from 1995. In his accompanying music video, Jackson dolefully sings on the set of a barren forest, with intercut images of environmental destruction, animal slaughter and Armageddon-like battles. Horowitz begins *The Body Song* by playing this music video in reverse. Midway through, Jackson's despair galvanizes into a divine rage followed by a primordial sense of recreation. As if the world were "born again," images of the previous catastrophes are shown in reverse. Because of the palindromic structure of the original music video, the sequence of events in Horowitz's *The Body Song* remains the same: disaster occurs and is undone. However, the artist's reversal creates an inversion of Jackson's emotion, and in a way, a reversal of his public persona. While he is perceived in popular culture as kitschy, fey and fragile, in Horowitz's reversal the ecstasy intended to communicate joy is recast to bring about destruction. In Horowitz's words, "In my version, Michael projects his personal anguish from his repressed self onto the world."[1]

This remake of "The Earth Song" takes Jackson's mythic persona and combines it with an apocalyptic tale. Jackson is a complex, epic character in popular culture, and Horowitz is not the first artist to use him as subject matter. Andy Warhol, Yasumasa Morimura and Jeff Koons have all made work about Jackson, perhaps because of his peculiar mix of weakness and power. The palindrome format emphasizes both his frailty and his strength, as well his relationship to the extremes of time, where he is both a lasting icon, and a temporary celebrity in the fickle pantheon of camp.

1. Artist statement, 1999

00:59

Jonathan Horowitz
The Body Song, 1997
VHS videotape
6:00 minutes

JULY 14, 1974

MY FATHER DIED
THE DAY I BOUGHT
AN AIRPLANE
TICKET TO GO TO
SEE HIM
I CALLED SHIRLEY
CLARKE. SHE ASK-
ED ME HOW I WAS.
I TOLD HER I WAS
CRYING. SHE SAID
"WHY DON'T YOU
MAKE A VIDEOTAPE
OF YOURSELF CRY-
ING"

Shigeko Kubota

My Father, 1973-75

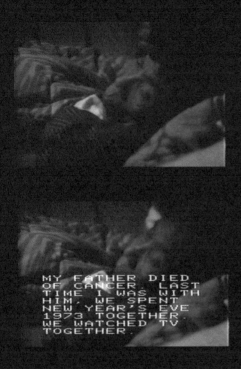

Since 1970, Kubota has kept an extensive video diary, chronicling both the heightened and the ordinary moments of her personal life. With her roots in the Fluxus movement, she approached video asking questions about the role of art and the artist, and about the relationship between an action and documentation, the timeless and the occasional, and art and life. Her video diaries often contain text, and in the spirit of Fluxus, tend to favor the overlooked and unremarkable aspects of a day rather than life's more dramatic moments.

My Father intersperses intimate scenes of the artist crying after learning of the death of her father, with clips from their last visit together in a Tokyo hospital. "Father, why did you die?" Kubota pleas while crying before the static and glow of a television. Later we see Kubota and her suffering father sharing New Year's Eve in the hospital, watching a banal pop music program on television. In every scene, whether in solitary mourning or with her father, video and television play a central, ritualized role, as a companion, as a witness, and as a way of invoking her father's presence after death.

00 : 6 1

Kubota's *My Father* is a testimony to video's capacity to recall life as it was lived in real time, serving as both witness and memory.

Shigeko Kubota
My Father, 1973–75
single channel video, black & white
15:24 minutes

Courtesy Electronic Arts Intermix, New York

TIME AS ACTIVITY

The work is divided into three different parts.

I. DUSSELDORF BETWEEN 11.25 am. to 11.29 am.

II. DUSSELDORF BETWEEN 3 pm. to 3.4 pm.

III. DUSSELDORF BETWEEN 5 pm. to 5.4 pm.

For this film, I selected three different places in Dusseldorf city where the activities show how people use the city.

1. around the Städtische Kunsthalle building.

2. a view of Königsallee from Th. Körner Str.

3. an aerial view of the commercial centre of the city.

What occurs on the screen has no aesthetic meaning. The projections show just time in the city where Prospect takes place.

12 minutes were selected from the 24 hours of activities in the city routine.

This routine is composed of a series of actions which take place at the same time, conditioned and limited by the boundaries of the city.

DAVID LAMELAS September 69.

David Lamelas

Time as Activity (Düsseldorf), 1969

Characteristic of the work of David Lamelas is an interest in providing the viewer with structure rather than content or information. His works are not intended to add to the viewers' knowledge or even visual repertoire, but to create the context for a kind of self-analysis by providing them with a new way of looking at their own familiar activities. Lamelas often finds his ideas in information that is relevant to each of our lives and the viewer should be able not only to understand the ideas in the film, but to link the film to his or her own activity of watching it.

Produced for the "Prospect 69" exhibition at the Kunsthalle Düsseldorf, *Time as Activity* uses photography and film shot in three different locations around Düsseldorf. The Kunsthalle, a fountain on a main street, and an intersection in the commercial center were each filmed for four minutes from a static position, the artist functioning as a *flâneur.* Lamelas states, "I was consciously working with time in this piece. The concept was the structure, or deconstruction, of time in Düsseldorf, where the film was made and shown."[1] The work is intended to be shown in a room with the projector exposed and present in the room, a strategy Lamelas often employs to disclose the self-consciousness of the exhibition. "It worked like a time projector, projecting another time than the real time."[2] Relating time to the architecture and mood of the city, Lamelas also superimposed the structure of time over the structure of the city.

1. *David Lamelas: A New Refutation of Time* (Rotterdam: Witte de With, 1997), p. 16.
2. Ibid., p. 61.

David Lamelas
Time as Activity (Dusseldorf), 1969
16mm film
12:00 minutes

Private collection, Cologne
Courtesy Galerie Kienzle & Gmeiner, Berlin
& Galerie Gisela Capitain, Cologne

Stephen Murphy
Untitled (Butterflies), 1998

A pastoral field, maybe in Switzerland or Colorado, vibrates from the flurry of butterflies fluttering their wings. The landscape contains every plausible idyllic element: a blue sky, mountains in the distance, a pine forest, a pond, wild flowers, and of course, butterflies. This is an image of how we might like to remember the experience of nature – completely devoid of its negatives (bugs, dirt, harsh climate) and abundantly lush (the butterflies, the field flowers, etc.). It is a scene that is more real than the real. In fact, it is entirely unreal, since everything about the work was digitally fabricated.

Stephen Murphy's *Untitled (Butterflies)* embraces the history of the landscape in painting and, to a lesser degree, photography. Because it runs on a continuous loop, the landscape appears to be constant. The only motion is the flapping of the butterflies' wings. Since the work contains both the elements of a static image and the visual swirl of the moving image, it suggests an interesting hybrid between canvas and monitor. Murphy has replaced the importance of light in painting with the essentialness of perpetual motion in video. His work seeks to meld the timelessness of painting with the temporality of video. It is as if a pastoral landscape painting had begun to breathe, in perpetuity.

00:65

Stephen Murphy
Untitled (Butterflies), 1998
VHS videotape
continuous loop

Courtesy 303 Gallery, New York

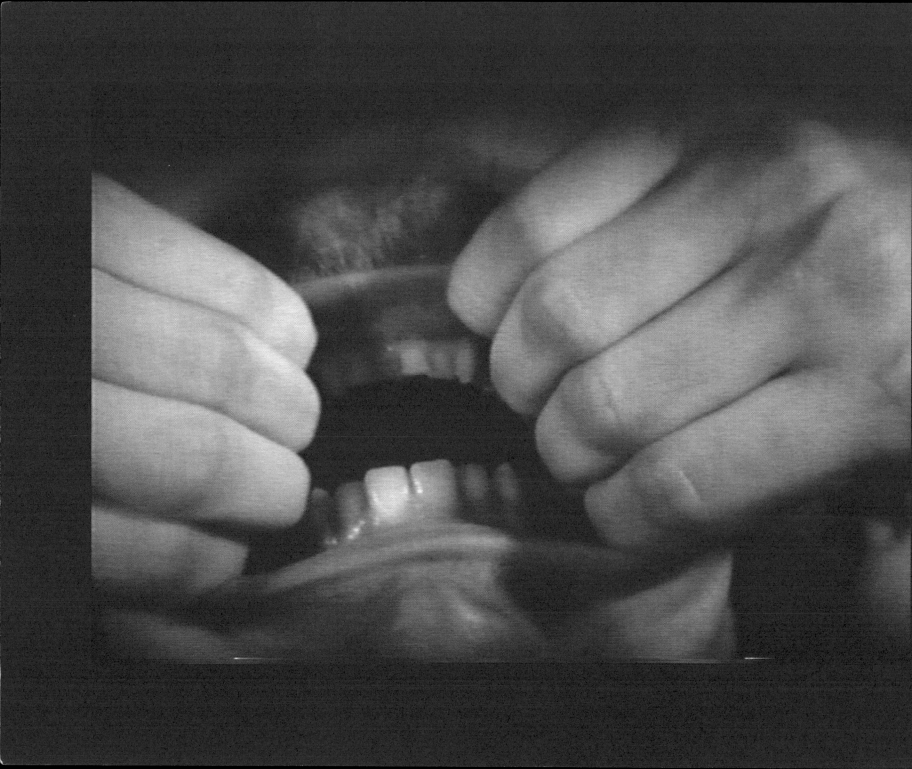

Bruce Nauman
Pulling Mouth, 1969

In the late 1960s, the artist-icon Bruce Nauman began recording his performances, done for the most part privately in his studio. At first, Nauman used film simply to document. Upon realizing the possibilities of the moving image for artistic applications, he started playing with camera angles and manipulating time. He began to make films that lasted roughly ten minutes (*Pulling Mouth* is eight minutes), the duration of a standard roll of 16 milimeter film. Using an industrial film camera, Nauman was able to shoot up to 4,000 frames per second to create what is referred to as his Slo-Mo films, including *Pulling Mouth*. These works were intended to run on an endless loop. In this piece, he distorts his mouth by inserting his fingers into it and pulling outward. His mouth is screened upside down and the viewer is treated to a very tight close up. Although Nauman was working with video in the late 60s and 70s, it was easier at the time to use film for a piece that was to run continuously.[1]

Nauman's Slo-Mo films emphasized time – both as it related to the films and the viewer watching the films – and made it obvious. In *Pulling Mouth*, his actions have been slowed so much that every detail is magnified and time seems trapped by its own need to move forward.

Bruce Nauman
Pulling Mouth, 1969
16mm film, black & white
8:00 minutes

Courtesy Electronic Arts Intermix, New York

1. Paul Schimmel, "Pay Attention," in *Bruce Nauman* (Minneapolis: Walker Art Center, 1993), p. 73.

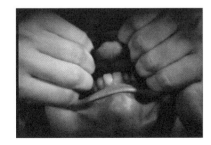 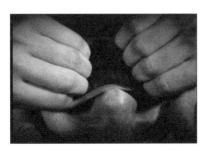 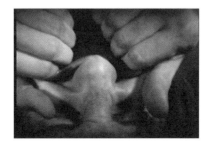

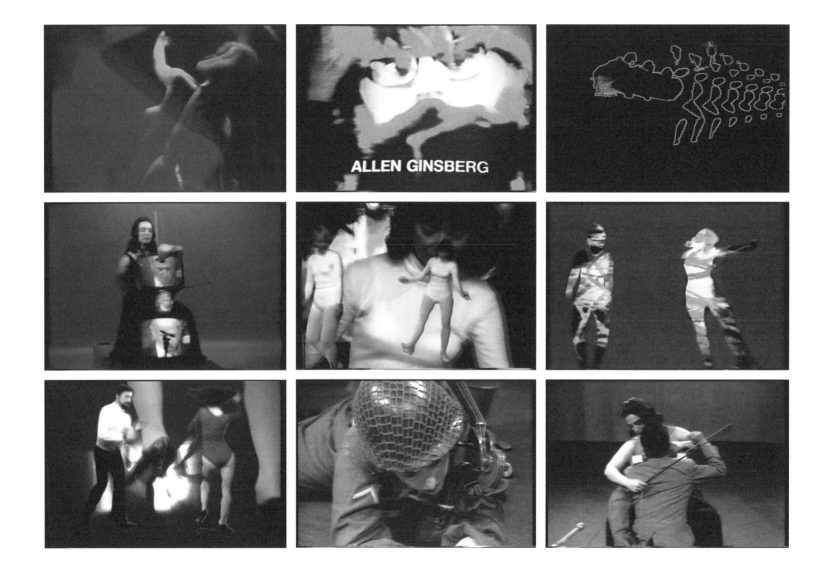

Nam June Paik

Global Groove, 1973

In 1965 when Sony introduced the Portapak, the first portable video recording device, Nam June Paik was among the first to acquire one and use it as a creative medium. He is often called the "father of video art"; and it is clear that without his pioneering talents, video art would not be where it is today. It is thought that Paik made the first publicized video documentary. Shot from the back of a New York City taxi, Paik shot tape of the Pope's visit to New York, and screened it later that evening at Café a Go Go. So mythic is Paik's status that "it is suggested that he lay all the groundwork [...] in freeing video from the domination of corporate TV [and allowing] video to go on and do other things."[1] While Paik has produced numerous works that suit the tenets of "Making Time," *Global Groove*, originally made to air on New York City public television, was selected for its utopian spirit, its predictions for the future, and for the way it distinguishes between the concept of time in television and video.

"This is a glimpse of the video landscape of tomorrow, when you will be able to switch to any TV station on the earth, and TV Guide will be as fat as the Manhattan telephone book." Thus begins *Global Groove*, Paik's revolutionary manifesto on the media-saturated world and Marshall McLuhan's notion of "the global village." In this vibrant video collage, Paik celebrates cultural figures like John Cage and Allen Ginsberg, alongside Japanese television commercials, Korean folk dancers, rock and roll, and Richard Nixon. In what Paik termed "Participation TV," a voiceover asks viewers to open or close their eyes (certainly the artist was well aware of the cost of video broadcast time on television). This act subverts one of the basic principles of television. In television, sequencing and narrative rule, and time must flow seamlessly without acknowledging its own fleeting nature. In addition, television asks the viewer to stay with it in the present – not seek to backtrack, accelerate, or turn inward to an interior space. Paik's sense of video time comes from a neo-Dada point of view, perhaps influenced by his early involvement with the Fluxus movement. His sense of video time entails temporal shifts, from stasis to acceleration to staccato to stream-of-consciousness visions, disruptive editing and incongruous juxtapositions.

Director: Merrily Mossman. Narrator: Russell Connor. Film Footage: Jud Yalkut, Robert Breer. Produced by the TV Lab at WNET/Thirteen.

0 0 : 6 9

1. Martha Rosler. "Video: Shedding the Utopian Moment," in *Illuminating Video: An Essential Guide to Video Art*, eds. Doug Hall & Sally Jo Fifer, (New York: Aperture, 1990), p. 44.

Nam June Paik
Global Groove, 1973
color VHS video
28:30 minutes

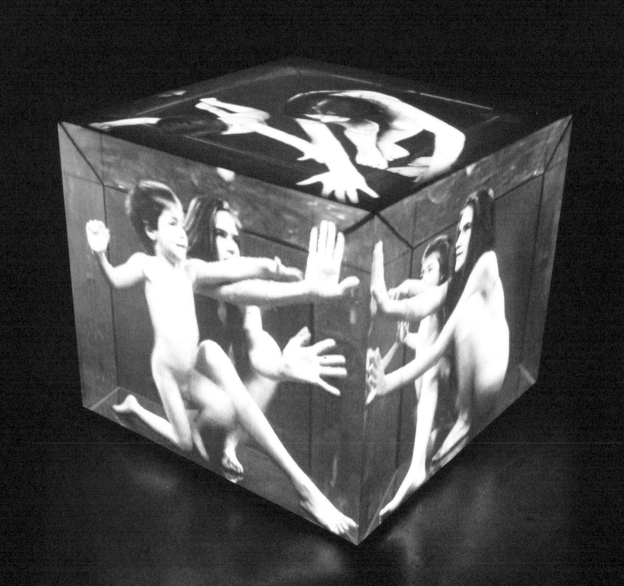

Peter Sarkisian

Hover, 1999

It begins with a statement on the nature and physicality of Minimalist sculpture, of the type divined by Donald Judd. A three-foot cube sits pedestal-less on the floor in the center of a semi-darkened room. Suddenly, the white cube is illuminated internally and a naked, seated woman appears holding a small boy, who is also naked. In art history and mythology, this scene recalls the Virgin Mary and Christ Child, Isis holding Horus, Aphrodite swaddling Eros. Very slowly, they begin to move, as if they have just been hatched and are coming to life. The mother and son embrace and gradually begin moving faster, until their motion seems to be in real time. The accompanying audio sounds like heavy machinery that relies on water to operate. They begin testing the boundaries of the cube by touching the six planes with their hands and feet, trying to stand slightly, twisting and turning within it. Their pace then quickens to an anxious, frantic one, almost too fast to watch without experiencing dizziness. At the end of the eight-minute loop, they vanish – ashes to ashes, dust to dust. We are left with a blank cube, this time a cool gray.

Sarkisian has created a powerful, illusionary work that links our peaceful, primordial sense of time (mother/child oneness) with the anxiety of the accelerated time of today (speed, mechanical sounds, the agitation of being contained). While they seem at ease, the cube in which the figures exist is an allusion to a cage or a prison, which is always linked to time, and to life and death. The art critic Dave Hickey has written on the idea of pictorial illusions in art and its inextricable relationship to time. Illusions, he writes, "are always about time – time past, remote or imagined – and are always a matter of timing."[1]

1. Dave Hickey, "A Matter of Time: On Flatness. Magic, Illusion. and Mortality." *Parkett*. #40/41, 1994, p. 166.

00:71

Peter Sarkisian
Hover, 1999
mixed media and video projection
11:30 minutes

Courtesy I-20 Gallery, New York

Steina

Orbital Obsessions, 1975-77 (revised 1988)

Lauded as a true video pioneer, Steina, along with her husband Woody Vasulka, began making videos soon after the first video recording device, the Portapak, was invented in 1965. From the very beginning Steina was interested in experimenting with the mechanisms of video, which included the construction of mechanical devices to program the camera to move by itself. *Orbital Obsessions* was part of the artist's "Vision Machine" project, which involved the use of a machine that was connected to the camera during shooting. The "Vision Machine" would move the camera around according to its own system in an effort to create works that were uninfluenced by the idiosyncrasies of the human eye.

Steina is well-known for using video feedback in her work. Feedback allowed the artist to design a "system of something observing itself reporting on itself, interactively."[1] Visually, her works are encoded and layered, constantly in motion. Trained as a classical violinist, Steina relies on sounds to guide her into images. *Orbital Obsessions* includes excerpts from *Signifying Nothing* (1975), *Sound and Fury* (1975), *Switch! Monitor! Drift!* (1976) and *Snowed Tapes* (1977). In these pieces, Steina focuses on time, space and movement, and the means by which the mechanical can inform and engage with electronic media. Steina writes, "Ordinarily the camera view is associated with a human view point, paying attention to the human conditions around the camera. In this series the camera conforms to a mechanized decision-making of instruments.... I am also paying attention to time accumulation, in a mix of real time with time inherited from each previous generation of pre-recorded and then re-taped segments."[2] Conflating the mechanics of video with the mechanics of time, Steina's work is seminal in understanding the primary structures of video.

1. Chris Hill, Interview with Steina and Woody Vasulka, (http://www.wings.buffalo.edu/academic/department/AandL/media_study/intervs/vasulka.html)
2. http://www.eai.org/qry/eai/catalogue

Steina
Orbital Obsessions, 1975-77 (revised 1988)
VHS video, black & white
24:55 minutes

Courtesy Electronic Arts Intermix, New York

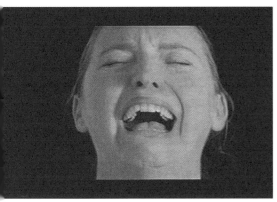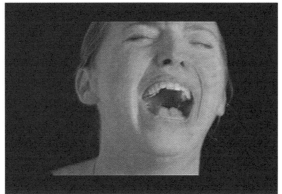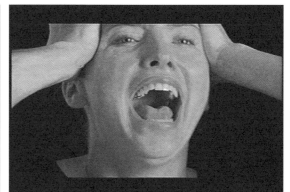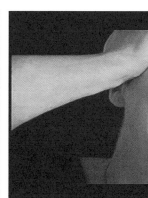

Sam Taylor-Wood

Hysteria, 1997

A lovely woman, filmed in close-up in front of a black screen, is overcome by a powerful emotion. Her actions are in slow motion, allowing the viewer to focus closely on her contorted facial expressions. There is no sound to clarify the nature of her emotion. She is not the least bit self-conscious, and there is no context for her actions. She appears at first to be in a fit of gut-splitting laughter. It is not long after that the viewer begins smiling, caving in to the contagious laughter. As the eight-minute loop progresses, it is unclear whether she is laughing or crying, or vacillating between the two. The intimacy of the camera brings the viewer close to the subject and her emotions, and this proximity leaves the viewer confounded as to his or her own emotions.

Sigmund Freud had many evolving theories about the medical condition of hysteria. Because the word shares an etymological origin to both the Latin and Greek words for *womb*, and because Freud was Freud, hysteria is a condition that has historically mostly been thought of as specific to women. For Freud, hysteria meant an irreconcilable position between primal sexual desires and Victorian society's taboos. In contemporary culture, hysteria is rarely used as a term to describe women in their wilder moments. By titling the work *Hysteria*, Taylor-Wood refers to Freud as well as to her own work, which is often concerned with isolation, boredom and psychological uneasiness.

Taylor-Wood creates a fixed space with the camera, and all action is confined to this box. The subject bobs up and down throughout until at the end, the woman's head falls out of range. She is with us, and then she leaves. Having no context or sound, and being separate from the real time of the emotional experience, *Hysteria* amounts to the dissolution of narrative structure, which inherently means a disjointed temporal experience.

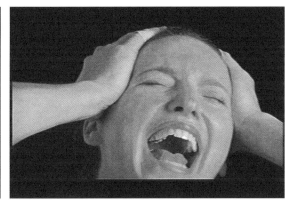

Sam Taylor-Wood
Hysteria, 1997
laserdisc projection
8:00 minutes

Courtesy Jay Jopling/White Cube, London

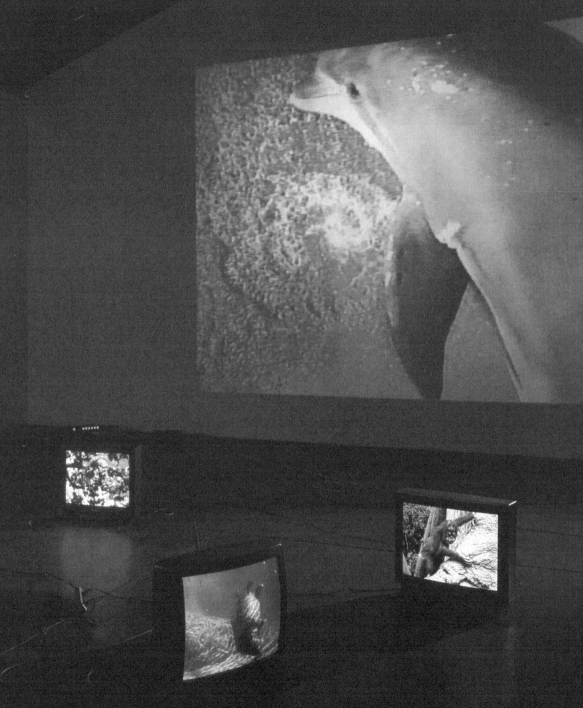

Diana Thater

The Caucus Race, 1998

The distinction between nature and culture is the primary subject matter of the work of Diana Thater. Happenings in the animal kingdom are rendered psychedelic – swirling images, flashes of light, jump cuts of speed and color. The artist frequently designs her installations to include the viewer's presence and movements. Though her subject matter is quite dreamy, her installations are intentionally punctuated with our own harsh shadows, as if to prompt reflection on our own complex and contradictory relationship to animals and nature.

The Caucus Race takes its title from a chapter in Lewis Carroll's *Alice in Wonderland*. The text from this chapter is projected one word at a time onto the wall in pop-inspired carnival colors. The chapter describes a jumbled race organized by a dodo bird in which animals of all forms participate. In the end, the dodo declares all of them winners, and each is awarded a prize. When the text is complete, an electric menagerie of animals and their man-made natural environments – a giraffe, an orangutan, hippos, tree tops – appear on monitors for a few brief seconds, again one at a time. Then a large projection appears: a big pool of blue water with a dolphin jumping toward us (and the camera) for a close-up greeting. There is something startling about the way the animals appear tender and approachable before the viewer and then instantly disappear, as if to comment on their own mortality.

By sequencing the text word-by-word, and arranging the images of the animals one-by-one, the artist creates an anti-hierarchical narrative structure that is contingent upon the sameness of the time-space between the previous image and the subsequent one. By swapping speed (which we associate with races) with slowness, Thater has trapped the viewer in the animals' laggard race to nowhere, where everyone is a winner and time bounds forward only to find itself where it was.

00:77

Diana Thater
The Caucus Race, 1998
video installation
continuous loop

Courtesy David Zwirner Gallery, New York

Type A
(Adam Ames & Andrew Bordwin)

Urban Contests, 1998

A pair of handsome young men, embodying the virtues of masculinity, compete with each other in bizarre challenges. In their contests, they engage elements of the city as their battleground: "No Parking" blockades, ladders leading to water towers, the structural columns of a parking garage, a men's public restroom. Choosing the domain of male competition, Adam Ames and Andrew Bordwin borrow from Hollywood's cinematic trope of the "guy flick." This genre is primarily indebted to the character James Bond, whose films taught two generations of men how to be a modern cowboy against the gritty background of modern life. More recently, Chuck Norris's films have taken their place, but without the high style favored in Bond's world. Ames and Bordwin's work is both an homage and a parody of Bond and Norris. The competitive conquests of Bond and Norris (flocks of women, gun cartels, international espionage, etc.) are very different from those of Type A. Is it the difference between men and boys, between the heroic and the anti-heroic? No, it is the difference between the ontology of Hollywood and of the art world.

The artists' competitions center mainly on speed and duration: how fast one can hurdle concrete pylons in a specific order, race to the top of a water tower, run around columns in a figure eight and (the finale) for how long one can urinate. As a narrative, each of these "contests" has a beginning, middle and end. The end generally reveals the results of the competition. As is the case in *Urban Contests*, video's anti-heroic dedication to real time encourages the tape to run uninterrupted and treat every moment as if equal.

00 : 79

Type A (Adam Ames and Andrew Bordwin)
Urban Contests, 1998
VHS videotape
5:10 minutes

Courtesy the artists

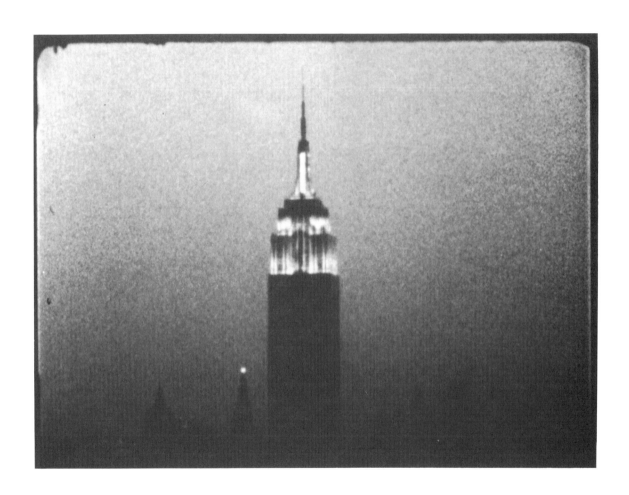

Andy Warhol
Empire, 1964

"If I am going to sit and watch the same thing I saw the night before, I don't want it to be essentially the same – I want it to be exactly the same. Because the more you look at the same exact thing, the more the meaning goes away, and the better and emptier you feel." [1]

Among Andy Warhol's most famous works might be his silk-screened portraits of Marilyn Monroe, or perhaps his paintings of Campbell's soup cans, both subjects being popular icons of American culture. For certain, his most famous film must be *Empire.* At eight hours and five minutes, very few people have seen it in its entirety, but most know what the film is about. The writer Stephen Koch describes the work like this: "The camera gazes for a full eight hours of moronic unmoving rapture at New York's venerable 102-story monstrosity while the sun majestically sinks through the afternoon towards darkness in an all too literally breathtaking smog." [2]

Fixing on the same thing for more than eight hours, Warhol assigns value to the Empire State Building, the same way that repeating Marilyn, Brillo boxes, Campbell's soup cans or dollar signs imbues each of them with cultural currency. Because *Empire* is not really a single image, but the same tiny image repeated over and over again on a strip of film, it bears a relationship to his repeated silk-screens on canvas. Repeating elements over and over again might make the meaning go away, but it also produces a kind of hollow fame and popularity, as Warhol wanted. By emphasizing the static quality Warhol aspired to with *Empire* (a sense of something constant, and above the need for context) he effectively slowed the modernist rush by stopping time. Like many of Warhol's films where the camera and subject share no real symbiosis, the viewer ends up having the same point of view as the camera – complete attention and total distance. [3]

1. Andy Warhol and Pat Hackett, *POPism: The Warhol 60s* (New York: Harcourt Brace Jovanovich, 1980), p. 50.
2. Stephen Koch, *Stargazer: Andy Warhol's World and His Films* (New York: Praeger, 1973), pp. 59-60.
3. Jean-Christophe Royoux, "The Narrative Landscape, or, the Fate of Cinema in the Era of Its Reproduction," in *Perfect Speed* (Guelph, Ontario & Tampa, Florida: MacDonald Stewart Art Centre and University of South Florida Contemporary Art Museum, 1995-96), p. 18.

Andy Warhol
Empire, 1964
16mm film
8 hours 5 minutes

Courtesy The Andy Warhol Museum, Pittsburgh, PA,
a museum of the Carnegie Institute

Photo Credits

Vito Acconci
Photo: Courtesy Electronic Arts
Intermix, New York

Darren Almond
Photo: Courtesy Jay Jopling/
White Cube, London

Francis Alÿs
Photo: Courtesy Lisson Gallery,
London

Alex Bag
Photo: Courtesy Colin de Land/
American Fine Arts,
New York

John Baldessari
Photo: Courtesy Electronic Arts
Intermix, New York

Lynda Benglis
Photo: Courtesy Video Databank,
Chicago

Andrea Bowers
Photo: Sara Meltzer's on view...,
New York

Stan Douglas
Photo: Courtesy David Zwirner,
New York

Fischli/Weiss
Photo: Courtesy Electronic Arts
Intermix, New York

Ceal Floyer
Photo: Courtesy Lisson Gallery,
London

Dara Friedman
Photo: Courtesy the artist
 Yves Klein
 Leap into the Void
 Photo: Courtesy the Estate of
 Yves Klein

Gilbert & George
Photo: Courtesy Electronic Arts
Intermix, New York

Douglas Gordon
Photo: Courtesy Gagosian Gallery,
New York

Rodney Graham
Photo: Courtesy 303 Gallery,
New York

Lucy Gunning
Photo: Courtesy Greene Naftali
Gallery, New York

José Antonio Hernández-Diez
Photo: Courtesy Eduardo Ortega

Gary Hill
Photo: Courtesy Electronic Arts
Intermix, New York

Jonathan Horowitz
Photo: Courtesy Greene Naftali
Gallery, New York

Shigeko Kubota
Photo: Courtesy Electronic Arts
Intermix, New York

David Lamelas
Photo: Barney Schaub
Courtesy the artist, Galerie Kienzle
& Gmeiner, Berlin and Galerie
Gisela Capitain,
Cologne

Stephen Murphy
Photo: Courtesy 303 Gallery,
New York

Bruce Nauman
Photo: Courtesy Electronic Arts
Intermix, New York

Nam June Paik
Photo: Courtesy Electronic Arts
Intermix, New York

Peter Sarkisian
Photo: Courtesy I-20 Gallery,
New York

Steina
Photo: Courtesy Electronic Arts
Intermix, New York

Sam Taylor-Wood
Photo: Courtesy Jay Jopling/
White Cube, London

Diana Thater
Photo: Fredrick Nielsen, Courtesy
David Zwirner Gallery, New York

Type A
Photo: Courtesy the artists

Andy Warhol
Film Still: Courtesy The Andy
Warhol Museum, Pittsburgh, PA,
a museum of the Carnegie Institute

Exhibition Checklist

Vito Acconci
Centers, 1971
Single channel black & white video
22:28 minutes
Courtesy Electronic Arts Intermix,
New York

Darren Almond
Time and Time Again, 1998
Video projection with
sound and clock
continuous loop
Courtesy Jay Jopling/White Cube,
London

Francis Alÿs
Zócalo, 1999
DVD projection
12 hours
Courtesy Lisson Gallery,
London

Alex Bag
Fall 95, 1995
VHS videotape
57:00 minutes
Courtesy Colin de Land/
American Fine Arts,
New York

John Baldessari
**Four Minutes of Trying to Tune
Two Glasses (for The Phil Glass
Sextet),** 1976
Single channel black & white video
4:09 minutes
Courtesy Electronic Arts Intermix,
New York

Lynda Benglis
Document, 1972
Single channel black & white video
6:08 minutes
Courtesy Video Data Bank,
Chicago

Andrea Bowers
Waiting, 1999
Laserdisc, laserdisc player,
video projector, metal bracket,
plexiglass
continuous loop
Courtesy Sara Meltzer's on view…,
New York

Stan Douglas
Evening, 1994
Video installation
14:52 minutes/each rotation
Courtesy David Zwirner Gallery,
New York

Fischli/Weiss
**Der Lauf der Dinge (The Way
Things Go),** 1987
Color film
30:00 minutes
Courtesy Matthew Marks Gallery,
New York

Ceal Floyer
Ink on Paper (video), 1999
VHS videotape
1 hour 55 minutes
Courtesy Lisson Gallery,
London

Dara Friedman
Total, 1998
16mm film loop,
optical sound track,
16mm sound film projector,
film looper, wood and
plexiglass plinth
12:00 minutes
Collection Carlos & Rosa de la Cruz,
Key Biscayne, FL

Government Cut, 1998
VHS videotape
continuous loop
Courtesy the artist

Gilbert & George
Singing Sculpture, 1971/1991
Color film (by Phillip Haas)
29:00 minutes
Courtesy Sonnabend Gallery,
New York

Douglas Gordon
Bootleg (Empire), 1997
VHS videotape
continuous loop
Courtesy Gagosian Gallery,
New York

Monument to X, 1998
Video projection
14:00 minutes
Courtesy Gagosian Gallery,
New York

Rodney Graham
Halcion Sleep, 1994
Video projection
26:00 minutes
Courtesy 303 Gallery,
New York

Lucy Gunning
Climbing Around My Room, 1993
VHS videotape
8:00 minutes
Courtesy Greene Naftali,
New York

The Headstand, 1995
VHS videotape
6:00 minutes
Courtesy Greene Naftali,
New York

José Antonio Hernández-Diez
Indy, 1995
Four VHS videotapes,
four monitors, wood pedestals,
skateboards
continuous loop
Collection Isabella Prata
& Idel Arcuschin,
São Paulo

Gary Hill
Around & About, 1980
Single channel color video
5:00 minutes
Courtesy Electronic Arts Intermix,
New York

Jonathan Horowitz
The Body Song, 1997
VHS videotape
6:00 minutes
Courtesy Greene Naftali,
New York

Shigeko Kubota
My Father, 1973-75
Single channel black & white video,
15:24 minutes
Courtesy Electronic Arts Intermix,
New York

David Lamelas
**Time as an Activity
(Dusseldorf),** 1969
16 mm film
12:00 minutes
Courtesy the artist,
Galerie Kienzle & Gmeiner, Berlin
and Galerie Gisela Capitain, Cologne

Stephen Murphy
Untitled (Butterflies), 1998
VHS videotape
continuous loop
Courtesy 303 Gallery,
New York

Bruce Nauman
Pulling Mouth, 1969
16mm film, black & white
8:00 minutes
Courtesy Electronic Arts Intermix

Nam June Paik
Global Groove, 1973
Color VHS video
28:30 minutes
Courtesy Electronic Arts Intermix,
New York

Peter Sarkisian
Hover, 1999
Mixed media and video projection
11:00 minutes
Courtesy I-20 Gallery,
New York

Steina
Orbital Obsessions, 1975-77
(revised 1988)
Black & white VHS videotape
24:55 minutes
Courtesy Electronic Arts Intermix,
New York

Sam Taylor-Wood
Hysteria, 1997
Video projection
8:00 minutes
Courtesy Jay Jopling/White Cube,
London

Diana Thater
The Caucus Race, 1998
Video installation
continuous loop
Courtesy David Zwirner Gallery,
New York

Type A
(Adam Ames & Andrew Bordwin)
Urban Contests, 1998
VHS videotape
5:10 minutes
Courtesy the artists

Andy Warhol
Empire, 1964
16mm film
8 hours 5 minutes
Courtesy Andy Warhol Museum,
Pittsburgh, PA, a museum of the
Carnegie Institute

Artists' Biographies

Vito Acconci
b. 1940, Bronx, New York
lives in Brooklyn, New York

The video work of Vito Acconci constructs the personal, interior world of the artist as a theatrical terrain. A fixed camera records in close-up the artist's monologues, confessions, and performative acts. On the tapes, Acconci engages the viewer directly through language, as if speaking to an intimate or interlocutor. The action unfolds in real-time, following the linear movement of language; time and language in fact become equal subjects of the work, complementing the artist's autobiographical self-presentation. For the viewer, the action is contiguous with the time spent in watching, situating him or her within the temporal space of the work. The boundaries between artist and viewer are subjected to constant re-negotiation in Acconci's work, bringing us closer to the mediated nature of our own lived experience.

Vito Acconci received a B.A. from Holy Cross College and completed an M.F.A. at the University of Iowa. The La Jolla Museum of Contemporary Art organized a 1987 retrospective of his work which traveled throughout the country. He has shown in one-person exhibitions at the Sonnabend Gallery, New York; the Museum of Contemporary Art, Chicago; the Köllnischer Kunstverein in Cologne, Germany; the Brooklyn Museum, New York; the Whitney Museum of American Art, New York; and the Museum of Modern Art, New York,

in addition to others. His writings have appeared in numerous art publications, including *October* and *Artforum*.

Darren Almond
b. 1971, Wigan, England
lives in London, England

The installations and live broadcasts of Darren Almond tunnel out spaces in which we are trained to expect drama – the artist's studio, the art gallery, the prison cell – revealing instead only emptiness and anxiety. The passage of time, as marked by clocks, dimming sunlight, or the silent rotations of a ceiling fan, is evacuated of all content. The spare, low-tech fixtures recall the hygienic sterility of the waiting room, or the creative sterility that accompanies production deadlines. Darren Almond graduated from the Winchester School of Art in 1994. He has received a one-person exhibition at White Cube, London and at the Renaissance Society of the University of Chicago, and was included in Gregor Muir's show at the Institute of Contemporary Art, London, "A Small Shifting Sphere of Serious Culture." Recently, his work was in "Sensation: Young British Artists from the Saatchi Collection" at the Brooklyn Museum.

Francis Alÿs
b. 1959, Antwerp, Belgium
lives in Mexico City, Mexico

The documentary aesthetic is fused to everyday lived experience in the laconic, conceptually-driven statements of Francis Alÿs. Video, film,

photography and paintings develop organically from the artist's walks through the city, celebrating the mundane even as they provoke social consciousness. Alÿs studied architecture at the Tournai, Belgium, and at the Istitúto di Architettúra di Venèzia. He has exhibited in the 1999 Venice, Istanbul, Melbourne and Santa Fe Biennales and in the 1998 Sao Paulo Bienal and the Fifth Havana Bienal. His work was also shown in the "Loose Threads" exhibition at Serpentine Gallery, London, as well as other group shows around the world. His work was recently featured in a solo exhibition at the Lisson Gallery, London.

Alex Bag
b. 1970, New York, New York
lives in New York, New York

Alex Bag's mock-satirical performances revel in the deconstruction of irony, illustrating how irony itself can now serve as the most naive of poses. Wearing her art-pop culture on her sleeve, she engages the viewer in diaristic vignettes and contemporary parables for the video age. Alex Bag received a B.F.A. from Cooper Union. She has had one-person exhibitions at 303 Gallery, New York; the Zaal de Unie, Rotterdam, The Netherlands; and the Andy Warhol Museum, Pittsburgh. In 1996 she was an artist-in-residence at the Dunedin Public Art Gallery in Dunedin, New Zealand. Her work was the subject of a solo exhibition at American Fine Arts, New York, in February 2000.

John Baldessari
b. 1931, National City, California
lives in Santa Monica, California

The video narratives of John Baldessari are built up from overlapping texts – spoken and written; photographic and filmed; recorded and reconstructed; imitative and original. A number of video works parody earlier works or contemporary art practice, indexing their moments of production in art history or within the artist's oeuvre. *Four Minutes of Trying to Tune Two Glasses (For The Phil Glass Sextet)* plays not only on the composer's name, but on the idea of time as a musical instrument. The six instruments forming the sextet are made up of two glasses and four minutes – matter or medium and temporality colliding on the level of artistic form, producing a thrust fault that betrays the instrumentality of time as a measure.

John Baldessari received a B.A. and an M.A. from San Diego State College. In 1990 the Museum of Contemporary Art, Los Angeles produced a major retrospective of his work that traveled widely throughout the United States. Solo exhibitions of his work have appeared at the Sonnabend Gallery, New York; the Contemporary Arts Museum, Houston; the Stedelijk Museum, Amsterdam; the Centro de Arte Reina Sofia, Madrid; and the Santa Barbara Museum of Art, California, among others. He has taught at Southwestern University, California; the California Institute of the Arts, Valencia; and the University of California at San Diego.

Lynda Benglis
b. 1941, Lake Charles, Louisiana
lives in New York, New York

Working in the mid-1970s, Lynda Benglis produced an influential body of video that commented unforgettably on the exchange of feminine identities within contemporary society. Benglis tracks the dizzying re-duplication of images, especially images of the self, as technology widens the gap between perception and presence. The role of this circulation and re-generation of images in shaping our self-perception is fore-grounded in major statements like *Home Tapes Revised* and *How's Tricks.* She has had numerous one-person exhibitions, including shows at Cheim & Read Gallery, New York, and Dorfman Projects, New York, in addition to participating in numerous group exhibitions worldwide. She teaches at the School of Visual Arts, New York.

Andrea Bowers
b. 1965, Wilmington, Ohio
lives in Los Angeles, California

The work of Andrea Bowers subverts the fundamental convention on which cinema and television rely to hold the viewer's attention: if we wait a little longer, something dramatic or entertaining will be shown, and what we have seen will be put in a context that we can learn from or enjoy. By endlessly deferring the starting-point of narrative, works like *Waiting* (1999) induce a psychological state entirely foreign to the experience of watching television or film.

Andrea Bowers received a B.F.A. at Bowling Green State University, Ohio and an M.F.A. at California Institute of the Arts, Valencia, California. She has had solo exhibitions at Sara Meltzer's on view…, New York; Dogenhaus Berlin; and the Santa Monica Museum of Art, to name a few. She has participated in group shows internationally.

Stan Douglas
b. 1960, Vancouver, Canada
lives in Vancouver, Canada

00:87

The suggestive multi-sensory allegories of Stan Douglas mine histories and perspectives effaced from memory or cultural consciousness. The unspoiled landscapes of the New World, music festivals of the the 1960s, archived news broadcasts and other ephemera find new lives in the present moment: Douglas believes that their potential force is not yet exhausted, that their continuing impact bears critical examination. Video works like his 1997 opus *Der Sandmann* (shown at "Documenta X," Kassel, Germany) expose the repression eternally at work at the very heart of the process of representation, the violence that applies even to self-representation, the construction of personal identity. Douglas reminds us that the leveling hand of time is in fact no more impartial than our selective memory, which chooses what it wants to forget, and how soon. Stan Douglas was a recipient of the 1998 Coutts Contemporary Art Foundation Award, Monte Carlo.

Fischli/Weiss
Peter Fischli b. 1952, Zurich, Switzerland
lives in Zurich, Switzerland
David Weiss b. 1946, Zurich, Switzerland
lives in Zurich, Switzerland

Fischli/Weiss have spent over twenty years perfecting the art of con-trolled chaos. Time-based processes of collapse and decay form the sub-ject of many of their works, engineered using conglomerations of everyday objects. Unlike the arrested moment captured in their trompe l'oeil sculptures of precarious balance, the video works track entropy and alteration as different programs of human or mechanical activity run their course. The jobs of gravity, of food preparation and of garbage disposal all carry equal weight for Fischli/Weiss as they chart the distri-bution of disorder throughout our small man-made universe. Efficiency and waste are not mere by-products of the artists' meticulous Swiss craftsmanship; rather, they are the inseparable twin engines of a sabo-tage that runs like clockwork.

Fischli/Weiss have participated in solo exhibitions throughout the world: at the University Art Museum, Berkeley, California; The Museum of Contemporary Art, Los Angeles; Centre Georges Pompidou, Paris; ARC Musée d'Art Moderne de la Ville de Paris; and their 1996 show, "Peter Fischli and David Weiss: In a Restless World," at the San Francisco Museum of Modern Art.

Ceal Floyer
b. 1968, Karachi, Pakistan
lives in London, England

Ceal Floyer's video documents directly confronts the viewer with ques-tions about the stasis and permanence of works of art. Is the work of art merely a secondary trace, or relic, of an act that is primary? In what ways does a drawn line or painted brushstroke differ from a photograph or film, since all of these products are referential, constituting an index of the lost moment of production, in addition to being iconic, that is, self-sufficient as visual images? What if the act itself can be represent-ed as a stationary or stationery image, so that the screen on which it is shown becomes a kind of paper, and the drawn trace of the artist's hand becomes, in fact, the artist's hand, as in *Ink on Paper* (1999)?

Ceal Floyer studied at Goldsmiths' College, London. She has had solo exhibitions at City Racing Gallery, London; Angel Row Gallery, Nottingham, England; Casey Kaplan Gallery, New York; and Lisson Gallery, London. She has shown in numerous group shows, including the book exhibition "Cream" (Phaidon Press, 1998) and the 11th Biennale of Sydney, Australia, 1998.

00:88

Dara Friedman
b. 1968 in Bad Kreuznach, Germany
lives in Miami Beach, Florida

The narratives of Dara Friedman tremble on the thresholds at which ulti-
mate boundaries are crossed – it is not the violence that is shown that
impresses, so much as the violence never admitted to view, the violence
from which the camera recoils. The action of *Government Cut* (1998) and
Total (1998) slows down or even reverses in order to defer the ultimate
moment of self-destruction, the moment to which the viewer's thoughts
are tending. Friedman received an M.F.A. at the School of Motion
Pictures, University of Miami; attended the Slade School of Fine Art,
London; and received a B.A. at Vassar College, Poughkeepsie, New York.
Her work has been shown in one-person exhibitions at the Museum of
Contemporary Art, Chicago; the Miami Art Museum; and the London
Filmmaker's Cooperative, London. She has recently been selected for
inclusion in the Whitney Biennial in 2000.

Gilbert & George
Gilbert b. 1943, Dolomites, Italy
lives in London, England
George b. 1942, Devon, England
lives in London, England

Vast, colorful swatches of modern life and the carnivalesque pervade the
art of Gilbert & George, even as rigidly formal methods of execution
serve to measure and confine the work. Historical and autobiographical
tracks and traces the viewer might be tempted to run away with are caged,
frozen, or preserved on display, chopped up, cut-out, and sent spinning
in circulation, like the painted horses of a musical carousel. Gilbert &
George themselves are almost always a primary subject in their work, as
are sex, youth culture and social issues of the day.

Gilbert and George met and studied at the St. Martins School of Art,
London in 1967. Since then, they have sacrificed their identities in
order to advance their artistic mission of interchangeability and their
existence as "living sculptures." They have had numerous solo exhibi-
tions around the world, including the Hayward Gallery, London,
Anthony d'Offay Gallery, London, Sonnabend Gallery, New York, the
Solomon R. Guggenheim Museum, New York and most recently, the
Gagosian Gallery in Los Angeles.

Douglas Gordon
b. 1966 in Glasgow, Scotland
lives in Glasgow, Scotland

Appropriating selected sequences from among the defining films of the
cinematic avant-garde, Douglas Gordon investigates the limits of artis-
tic form and human endurance. Seeds first sown by other artists are
gathered and re-planted by Gordon to produce new shoots - slowed-

00:89

down, reversed, caught up in the specular experience of an ever-changing public. Video is used as a tool for pruning back the narrative roots of time-based media, even as the image, the moment, is allowed to flourish in extravagant excess.

Douglas Gordon was a recipient of the prestigious Turner Prize in 1996, among many other awards and honors. He attended the Glasgow School of Art, Glasgow; and the Slade School of Art, London. He has shown internationally, including solo exhibitions at Gagosian, New York; Museum für Gegenwartskunst, Zürich; Centre Georges Pompidou, Paris; and the Kunstverein Hannover, Hannover, Germany.

Rodney Graham
b. 1949, Vancouver, Canada
lives in Vancouver, Canada

As never-ending passages, interludes, or intermissions, the videos of Rodney Graham satirize what is at stake in the continuity of consciousness across time – in waking up in the same bed where we went to sleep, for example. Artificially-induced unconsciousness seems like the only escape hatch for the bored or lonely individual unable to return home; yet it is the quest for mastery over time and space that has stranded him or her in the first place, and so the cycle repeats itself without end. Rodney Graham attended the University of British

Columbia. His work has been featured in solo exhibitions in Canada, the United States and Europe, including shows at 303 Gallery, New York; the Museum of Contemporary Art, Miami, Florida; Vancouver Art Gallery, Vancouver; Johnen & Schöttle Galerie, Cologne, Germany; Lisson Gallery, London; and in the Canadian Pavilion at the XLVII Venice Biennale.

Lucy Gunning
b. 1964, Newcastle upon Tyne. England
lives in London, England

The videos of Lucy Gunning recall a stage of pre-adolescence where everything appears possible and the rules of the physical universe seem to hold less force. Works like *Climbing Around My Room* (1993) domesticate the space of athletic performance, but at a cost to the dignity and "manliness" of sport – even as the woman traverses the walls of her room with almost superhuman agility, she slides down the maturational and evolutionary scale. In *The Horse Impressionists* of 1994, Gunning records five women who imitate the sounds and gestures of horses. Lucy Gunning studied at West Surrey College of Art and Design and at Goldsmiths' College, London. She has had solo exhibitions at Matt's Gallery, London; Adam Gallery, London; Chapter, Cardiff, Wales; and in Boston, New York, and other cities. Her work has been included in group shows worldwide since 1987. In 1994, she won the BT New Contemporaries Award.

José Antonio Hernández-Diez
b. 1964, Caracas, Venezuela
lives in Caracas, Venezuela

Stasis and motion fold back upon one another in the video installations of José Antonio Hernández-Diez. Between the compactness and portability of the camera and the immobility of the monitor (or screen), a dialectical opposition is generated. This juxtaposition furthermore mirrors other oppositions specific to the medium, such as independent versus studio-produced or youth culture versus establishment tastes. The roving meditations of Hernández-Diez investigate what we consider the proper vehicle for artistic production. Hernández-Diez has had solo exhibitions at Sandra Gering Gallery, New York and Sala RG in Caracas. His work has been included in many group shows internationally: Aperto, XLV Venice Biennale; "The Final Frontier," New Museum of Contemporary Art, New York; Fifth Havana Biennial; XXII São Paulo Biennial.

Gary Hill
b. 1951, Santa Monica, California
lives in Seattle, Washington

The video installations of Gary Hill showcase masterful arrangements of architectural space, video interface and verbal text. Trained as a sculptor, Hill manipulates the scale, size and shape of video screens as sculptural elements in his compositions, playing on their formal and metaphorical operations as windows, compartments and cages. This formal emphasis on the physical presence of the video monitor prevents the viewer from forgetting his or her own position in relation to what is seen. Video's utopian promise of the transcendence of time and space, of escape from the finite body, is exposed in Hill's paradoxical constructions as a trap. Philosophical texts from Maurice Blanchot and Wittgenstein are incorporated as spoken or printed fragments that overlay the video image, commenting on the absurdity of a strict division of consciousness from the body. In *Site/Recite (a prologue)* of 1989, the ending is shot by a miniature camera placed inside a mouth, filming the outside world through lips that part to form the words: "Imagining the brain closer than the eyes." The play of narrative and figuration balances the formal grandeur of Hill's video installations with an equally powerful expressiveness.

Gary Hill studied at the Arts Student League in Woodstock, New York. He has held teaching positions at the Center for Media Studies, Buffalo; the Cornish College of the Arts, Seattle; and Bard College, Annandale-on-Hudson. One-person exhibitions and retrospectives of his work have been held at the Whitney Museum of Modern Art, New York; The American Center, Paris; the Musee d'Art Moderne, Villeneuve d'Ascq, France; and The Museum of Modern Art, New York.

Jonathan Horowitz
b. 1966, New York, New York
lives in New York, New York

Feasting upon the video appropriations of Jonathan Horowitz affords the viewer something like an intravenous diet of popular culture. His interest in Hollywood, celebrity, corporate culture and maudlin emotion is genius and ceaseless. Despite the horrors of pop-cultural addiction and dependency, Horowitz teaches us that mainlining Michael Jackson and Hollywood blockbusters has its approved medical applications.

Jonathan Horowitz received his B.A. from Wesleyan University. Solo exhibitions of his work have been organized by Greene Naftali Gallery, New York; Project Room, Van Laere Contemporary Art, Antwerp, Belgium; Project Room, Ten in One Gallery, Chicago; Kenny Schachter/Rove, New York; and Millennium, New York. His work was recently included in "Regarding Beauty" at the Hirshhorn Museum and Sculpture Garden, Washington, D.C.

Shigeko Kubota
b. 1937, Nigata, Japan
lives in New York, New York

A leading member of the art group Fluxus in the 1960s, in the 70s Shigeko Kubota became a pioneer of video sculpture and installation. A

series of diaristic tapes called *Broken Diary* document her daily life and travels, including a meeting with the artist Marcel Duchamp in 1968. Duchamp was to serve as a model for additional works, such as the Duchampiana series, which included the video sculpture *Nude Descending a Staircase* of 1976. Inspired by the Duchamp painting of the same name, Kubota's work utilizes video footage of an actual nude, which plays on a series of linked monitors set into the steps of a free-standing staircase. In the place of Duchamps' pseudo time-lapse technique, Kubota offers an experience in real-time, while the replication of the video image on the different screens re-traces in three-dimensional space the virtual "trail" left behind by Duchamp's painted nude. Such re-appropriation of iconic works of art was to become a recurrent theme of postmodern artistic production in subsequent decades.

Shigeko Kubota received a B.A. in sculpture from the Tokyo University of Education before moving to New York in 1964 to study at New York University and the New School for Social Research. Kubota has taught at the School of the Visual Arts and served as artist-in-residence at the School of the Art Institute of Chicago and Brown University. In 1991, a retrospective of her work was organized by the American Museum of the Moving Image, New York. The Whitney Museum of American Art, New York featured a one-person show of her work in 1996.

David Lamelas
b. 1946, Buenos Aires, Argentina
lives in Berlin, Germany

The split personality of film, both information and aesthetic object, makes it the perfect vehicle of expression for institutional interrogationist David Lamelas. His work explores not only the differing contexts in which we receive information, but also the competition that arises internally between the different levels of information provided by the forms of mass media. This tension was the principal subject of the work he created for the 1968 Venice Biennale, *Information About the Vietnam War at Three Levels: The Visual Image, Text, and Audio*. In this film and in *Study of Relationships Between Inner and Outer Space* (1968-69), the significance of the content hinges on the surprise ending or punchline, an iconic image which also serves up narrative foreclosure.

David Lamelas attended St. Martins School of Art, London for postgraduate studies. In Europe he was associated with the artists Marcel Broodthaers and Daniel Buren. He moved to Los Angeles in the mid-1970s and again to New York in the late 1980s. His work was included in the influential 1995 exhibition "Reconsidering the Object of Art 1965-1976" at the Museum of Contemporary Art, Los Angeles. In 1997, he was given a retrospective, "A New Refutation of Time," at the Kunstverein Munchen, Germany; and the Witte de With Center for Contemporary Art, Rotterdam, The Netherlands.

Stephen Murphy
b. 1962, London, England
lives in London, England

Implausibly beautiful, yet often deeply unsettling, the digitally-generated tableaux of Stephen Murphy offer views that are all timeless exteriority. Erosion, death and decay are done away with, but at a cost – the crispness of Murphy's hyper-real visions excludes all the vagueness and ambiguity that define our humble existence on this planet. In *Untitled (Butterflies)*, 1998, it is the complexity of all higher forms of life and of the human presence in particular, that is excluded: the artist offers us a view of the world after the end of our age and asks if it might not be indeed more perfect than our own.

Stephen Murphy received a B.A. from St. Martins School of Art, London, and an M.A. from Goldsmiths' College, London. A solo exhibition of his work was held at 303 Gallery, New York in 1999. He has shown in group shows at The Showroom Gallery, London; Lisson Gallery, London; Greene Naftali Gallery, New York; Galerie Mot & Van den Boogard, Brussels; Hayward Gallery, London; Tanya Bonakdar Gallery, New York; and Transmission Gallery, Glasgow, Scotland, among others.

00 : 93

Bruce Nauman
b. 1941, Fort Wayne, Indiana
lives in Galisteo, New Mexico

Bruce Nauman's hard-edge Conceptualism invests philosophical questions with the uncomfortable immediacy of labored breathing or a thready pulse. The rhythm of speech, of walking, of bodily processes becomes the beat of the head against the wall or the fist against the door that won't open. The physical and psychological boundaries of the individual are the principle subjects of Nauman's work. In his performances, time becomes a mere index of the obsessional and repetitive character of self-expression. Following Jackson Pollock, he takes Dadaist and Surrealist practices such as "automatic writing" and scales them back to pure physical gesture, then empties the trace of all expressive value by recording it mechanically on videotape. The viewer is forced to relate to the performance viscerally, instead of rationalizing or romanticizing what is seen.

Bruce Nauman received a B.A. from the University of Wisconsin, Madison, and an M.A. from the University of California, Davis. He has had solo exhibitions at the Nicholas Wilder Gallery, Los Angeles; Leo Castelli Gallery, New York; and Galerie Konrad Fischer, Düsseldorf, Germany, among others. Retrospectives include "Bruce Nauman: Work from 1965 to 1972," organized by the Los Angeles County Museum of Art and the Whitney Museum of American Art and shows at the Rijksmuseum Kröller-Müller, Otterlo, The Netherlands; the Baltimore

Museum of Art; Museum fur Gegenwartskunst, Basel; the Whitechapel Art Gallery, London; and the Walker Art Center, Minneapolis.

Nam June Paik
b. 1932, Seoul, Korea
lives in New York, New York

Nam June Paik was one of the first artists to begin incorporating and manipulating video in his work. While first a student in Germany, and after he moved to New York in 1964, he was an extremely active member of the Fluxus movement. Early performances featuring altered musical instruments paved the way for experiments with re-engineered television sets. Television became an abiding fascination for Paik, and an integral element of his sculptural and environmental compositions. He was a pioneer of the concept of "interactive" television, which he believed held utopian promise for a new world civilization. Many of his video works result from collaborations with other avant-garde artists, such as Joseph Beuys and John Cage.

After studying music and art history at the University of Tokyo, Nam June Paik graduated with a degree in aesthetics in 1956. He went on to study at the Universities of Munich and Cologne, and the Conservatory of Music in Freiburg, Germany. Paik has shown in solo exhibitions at Holly Solomon Gallery, New York; Galerie Parnass in Wuppertal, Germany; the Tokyo Metropolitan Art Museum; and the Centre

00 : 94

Georges Pompidou, Paris, among many others. Numerous institutions have staged retrospectives of his work, including the Kölnischer Kunstverein, Cologne, Germany in 1976; the Whitney Museum of American Art, New York in 1982; and the Hayward Gallery, London in 1998. A major retrospective will be held in 2000 at the Guggenheim Museum, New York.

Peter Sarkisian
b. 1965, Glendale, California
lives in Santa Fe, New Mexico

Dramatically lit or shrouded in theatrical darkness, the installations of Peter Sarkisian cast video projections in unlikely sculptural forms. Minimalist cubes, balls, sleeping-pillows and martini-glasses retain their object-hood even as they serve as screens for the depiction of another filmed reality, one step removed from the present. These mixed-media projections recall the deformations of space that characterize certain horror films in which architectural spaces become metaphors for the penetrable human body – the body that is born, gives birth and dies.

Peter Sarkisian attended California Institute of the Arts and the American Film Institute. He has had one-person shows at I-20 Gallery, New York; University Art Gallery, San Diego, California; SITE Santa Fe, New Mexico; Machinenhalle, Brandenburgischer Kunstverein, Potsdam, Germany; Modernism, San Francisco; the Edinburgh International Festival, Edinburgh College of Art, Scotland; and others elsewhere.

Steina
b. 1940, Reykjavik, Iceland
lives in Santa Fe, New Mexico

Image and sound undergo alchemical transformations in Steina's video environments, which interface instrumental music, mechanical optics and camera footage with digital sources and mixing technologies. She employs time-based media as a means of apprehending change, modulation and growth. In describing her work, she explains that her musical education conditions her relationship to temporality in video. Conceptually, she does not approach video in terms of stills, but in terms of motion. Videos that incorporate landscapes from her native Iceland or the American southwest are manipulated so that rivers appear to flow uphill and seas well forth from the desert, subjecting entropy itself to Steina's systematic disordering of categories. *Violin Power*, an early work that is constantly being re-invented with each new performance, invests Steina's MIDI violin with the power to sequence frames of video in any order and at any speed. As an index of time's passage, video becomes infinitely malleable, even as it is folded within another, musical, form of temporal progression.

Steina studied at the Music Conservatory in Prague. After emigrating to the United States in 1965, she embarked in the early 1970s upon a series of seminal video works produced in collaboration with the artist Woody Vasulka, that have been exhibited internationally. Her individ-

00:95

ual works have been shown at the Centre Georges Pompidou, Paris; the Museum of Art, Carnegie Institute, Pittsburgh; the Jonson Gallery, University of New Mexico Art Museum, Albuquerque; and the Whitney Museum of American Art Biennial, New York, among numerous others. In 1996, she assumed the post of Artistic Co-Director for The Netherlands musical research center STEIM (Studio for Electro-Instrumental Music).

Sam Taylor-Wood
b. 1967, London, England
lives London, England

Since the early 1990s, Sam Taylor-Wood has been creating video, film, and photographic installations that exploit the incompatibility of certain sounds or silences with different forms of documentation. Some of Taylor-Wood's videos feature the unexpected absence of sound, as in the case of the silent laughter of *Hysteria* (1997), or the opera lip-synchers of the four-screen projection *Killing Time* (1994). In other cases, visual media are supplemented by disturbing juxtapositions of sound, as in 16mm's dance to machine-gun fire (1993). These disjunctions complicate any response to what we might consider positive or "artistic" display.

Sam Taylor-Wood received a B.A. from Goldsmiths College in 1990. Her work has been shown at La Fundacio "la Caixa," Barcelona; White Cube, London; and the Musée d'Art Moderne, Paris. She won the

award for most promising young artist in the exhibition "Future, Present, Past" at the 1997 Venice Biennale. Her work was included in "Sensation: Young British Artists from the Saatchi Collection" at the Brooklyn Museum.

Diana Thater
b. 1962, San Francisco, California
lives in Los Angeles, California

Diana Thater introduces exotic animals into a mundane technological environment in the hopes that our conception of nature will adapt. Her video works encourage the viewer to look beyond the simplistic opposition of natural versus constructed worlds, to discover the secret life-cycles governing technology and mediation. In certain works, videotape is divided into red, green and blue component images, thus revealing the determining role of human perception in the development of the medium. In others, video projections fill entire rooms, creating a simulated habitat for gallery-goers.

Diana Thater received a B.A. at New York University and an M.F.A. at the Art Center College of Design, Pasadena, California. She has shown in one-person exhibitions at the Carnegie Museum of Art, Pittsburgh, Pennsylvania; David Zwirner Gallery, New York; Patrick Painter, Santa Monica, California; Art Gallery of York University, Ontario; and the St. Louis Art Museum, St. Louis, Missouri.

Type A
Adam Ames b. 1969, New York, New York
lives in New York, New York
Andrew Bordwin b. 1964, Framingham, Massachusetts
lives in New York, New York

The artist team of Type A tosses out pointed barbs in the path of conventional success and masculine prowess. Satirizing the culture of extreme sports and motivational tapes, Type A critiques the unspoken assumption that "real men don't complain about gender stereotypes." Type A is Andrew Bordwin, who received a B.A. and a B.F.A. from New York University, and Adam Ames, who received a B.A. at the University of Pennsylvania and an M.F.A. from the School of Visual Arts, New York. They have participated in group shows at Thread Waxing Space, New York; Art in General, New York; Herbert F. Johnson Museum of Art, Cornell University, Ithaca, New York; Centro de la Imagen, Mexico City; Galerie Hubert Winter, Vienna; White Columns, New York; Sara Meltzer's on view…, New York; and many others. Each has shown individually in one-person exhibitions in the Untied States.

Andy Warhol
b. 1928, Forest City, Pennsylvania
died 1987, New York, New York

Pop-art innovator and cultural icon, Andy Warhol made famous the phrase, "In the future, everyone will be famous for fifteen minutes." His films of the 1960s and 70s, including *Sleep* (1963), *Empire* (1964), *The Chelsea Girls* (1966), *The Lonesome Cowboys* (1967), and *Flesh* (1968), seemed to have been conceived for a different sort of fame than he achieved with the landmark silkscreen paintings on the early 1960s. Too long and too weakly plotted to hold most people's interest and too scabrously sexual for widespread distribution in their own time, Warhol's films did not conform to any of the conventions of the medium. In their radical extensions of both reel-time and real-time, their substitution of readymade actors for actual celebrities and their disregard for conventional narrative, the films were in some ways the most subversive aspect of Warhol's artistic practice.

Andy Warhol graduated from the Carnegie Institute of Technology in 1949 with a degree in pictorial design. In 1964, he was given his first solo exhibitions at Leo Castelli Gallery in New York and Galerie Ileana Sonnabend in Paris. In 1965, his first solo museum exhibition was held at the Institute of Contemporary Art at the University of Pennsylvania. He went on to show almost continuously at institutions throughout the world. Andy Warhol's life and art have been the subject of innumerable retrospectives.

The exhibition design for "Making Time" is brought to you by the architectural team LOT/EK.

LOT/EK's design integrates electronic, organic and manufactured materials imported from the contemporary urban landscape.

LOT/EK's "raw materials" are prefabricated objects and technology, extracted from and consciously referencing the contemporary urban landscape.

LOT/EK creates a different interaction of the human body with the products and by products of industrial and technological culture.

LOT/EK blurs the boundaries between art, architecture and entertainment.

LOT/EK is Ada Tolla and Giuseppe Lignano, born and raised in Naples, Italy, graduates of the School of Architecture of the Universita' di Napoli (1989) and Post-Graduate Studies at Columbia University in New York City (1990-1991). They are based in New York City.

Computer generated schematic drawings for the installation of "Making Time" at Palm Beach/ICA.